IMAGES
of America

COLORADO &
SOUTHERN RAILWAY
CLEAR CREEK NARROW GAUGE

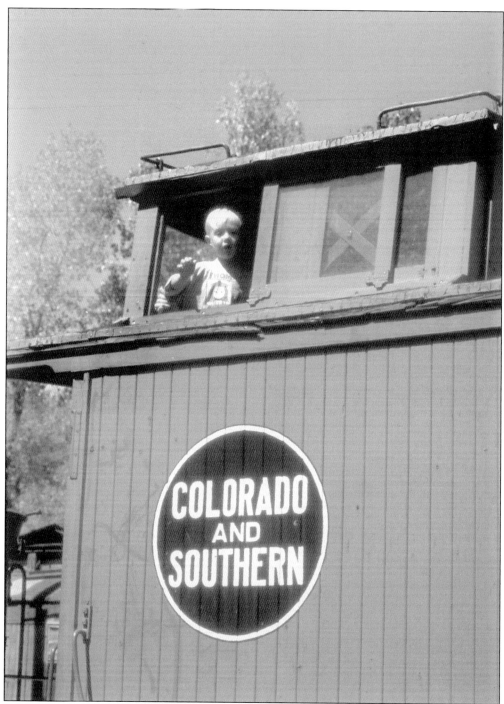

It has been more than 60 years since the trains of the Colorado & Southern Railway traveled along the banks of Clear Creek. Fortunately, a few pieces of narrow-gauge equipment have been restored and now serve as a reminder of the glory days of mountain railroading. In this photo, the author's son Joey peers through the cupola of a C&S caboose on display at the Colorado Railroad Museum.

IMAGES
of America

COLORADO &
SOUTHERN RAILWAY
CLEAR CREEK NARROW GAUGE

Allan C. Lewis

ARCADIA
PUBLISHING

Published by Arcadia Publishing
Charleston, South Carolina

Printed in the United States of America

Library of Congress Catalog Card Number: 2004104891

For all general information contact Arcadia Publishing at:
Telephone 843-853-2070
Fax 843-853-0044
E-mail sales@arcadiapublishing.com
For customer service and orders:
Toll-Free 1-888-313-2665

Visit us on the Internet at www.arcadiapublishing.com

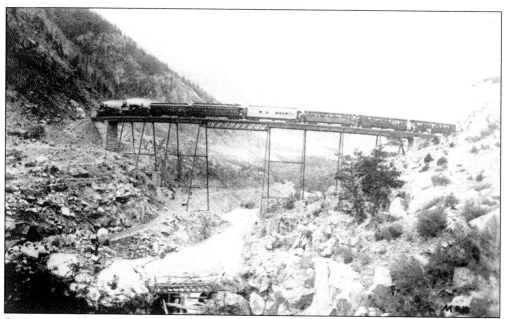

Serving as a tribute to a Union Pacific extension that was never built, the Georgetown Loop epitomized railroading on the Clear Creek Branch. In this 1890s photo, a double-headed passenger train loaded with tourists pauses for the photographer on the "High Bridge."

CONTENTS

ACKNOWLEDGMENTS

As with previous Arcadia projects, the author has shouldered a majority of the efforts entailed in the assembly of this book. However, I am greatly indebted to my friends and family, for without their support, this project would not have been possible. My wife, Pam, graciously allowed me the time to gather all of the data and was extremely helpful in generating ideas. My son Joey served as my companion on research trips. His interest in trains has helped to further my own enthusiasm. I am very fortunate to have the memory of my late father, Gilbert A. Lewis; the encouragement of my mother, Verna C. Lewis; Mary Jane Lewis; the McCollisters; and the rest of my family. Their support has been invaluable.

In addition, I would like to thank my friends P.R. "Bob" Griswold and Doug Summer, who allowed me to include artifacts and images from their collection in this book. I am also appreciative of the efforts of Steve Rasmussen, who helped to keep me grounded, focused, and in good humor.

This book is not intended to be an exhaustive history of the Colorado & Southern Railway or the Clear Creek Mining District. It is a pictorial account, which combines rare images (some previously unpublished) and original artifacts to illustrate the social and economic development of the Clear Creek region. The book also relates the economic impact made by local mines, communities, and the tourism that grew from these activities. It also chronicles the rise and fall of railroads that served the area.

Unless otherwise noted, all photographs are from the author's collection.

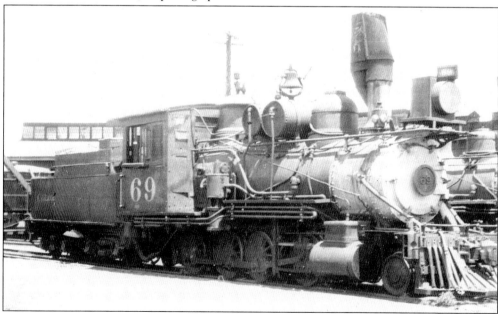

With its squared off headlight and bear-trap spark arrester, C&S Engine No. 69 rests near the Denver roundhouse waiting for her next run. This engine, along with several others in the C&S stable, lived to see the end of narrow-gauge operations in Clear Creek and helped to dismantle the track.

INTRODUCTION

Few places can stir the imagination of western history enthusiasts like Colorado's Clear Creek Valley. Here, in the mountains west of Denver, a handful of pioneers found large deposits of precious metals. The resulting gold rush became one of the precursors to the settlement of the West and signaled a new era in American history. By the mid-1860s, the collection of tents and log cabins that had lined the banks of Clear Creek had given way to more permanent structures. Out of these settlements came towns like Idaho Springs, Black Hawk, Central City, and Georgetown. These communities grew quickly, creating the need for an economic and reliable form of transportation. In 1869 Denver capitalist William A.H. Loveland seized this opportunity and incorporated the Colorado Central Railroad. The Colorado Central was extended west from Denver along Clear Creek reaching Black Hawk in 1872, Georgetown in 1877, and Central City in 1878. The line was then leased to the Union Pacific in 1879.

Union Pacific intended to use the Colorado Central and the newly formed Georgetown, Breckenridge & Leadville to reach the booming camp of Leadville. However, budgetary and geographic constraints forced the UP to abandon the idea in favor of the Denver, South Park & Pacific, which was already advancing on Leadville. By 1884 the lofty dreams of the Union Pacific had made the Colorado Central the beneficiary of almost nine new miles of track. This new line extended west from Georgetown and Graymont. One of the primary features of this new right-of-way was a 300-foot span called "High Bridge" and two miles of railroad engineering commonly referred to as "The Loop." By 1890, the Union Pacific had a strong if not complicated presence in Colorado and a decision was made to combine eleven UP subsidiaries, including the Colorado Central and the GB&L, into one company. The end result was the formation of the Union Pacific, Denver & Gulf. With both standard and narrow-gauge operations, the UPD&G combined with the Denver, Leadville & Gunnison to handle the UP's interest in the mountains and southern plains of Colorado. The economic crash of 1893 saw tough times for the Union Pacific and its subsidiaries. Despite falling into receivership, the UPD&G was able to weather these turbulent times. Eventually the economy improved and with the assistance of receiver Frank Trumbull, the financial health of the UPD&G returned. The line was eventually purchased by bondholders in 1898 and combined with the Denver, Leadville & Gunnison to form the new Colorado & Southern Railway.

The Colorado & Southern was not alone in the Clear Creek District. In 1886 construction began on the Gilpin Tramway, a two-foot-gauge railroad designed to serve the mines around Black Hawk and Central City. The line was completed in 1888 and used geared locomotives to haul ore and coal. In 1904 the 26-mile Gilpin Tramway was purchased by the C&S. Despite new ownership, however, ore traffic began to decline. The line was cut back to 16 miles in 1914 and then finally abandoned and scrapped in 1917. Another Clear Creek railroad project was the Argentine Central. Encouraged by the passenger traffic on the C&S, Edward Wilcox proposed the construction of the three-foot-gauge railroad from Silver Plume to Mount McClellan in 1905. This railroad became the Argentine Central and, like the Gilpin, used geared locomotives to handle the steep grades of its right-of-way. Although originally intended to haul ore, much of the Argentine Central's revenue was predicated on tourism. Accordingly, the decline in tourism a decade later signaled the demise of the railroad, and the 16-mile narrow-gauge line was abandoned in 1919.

World War I was a pivotal period for the Colorado & Southern. The war had created both marked inflation and the United States Railroad Administration, neither of which the Clear Creek line would recover from. Along with the inflation came coal shortages and a decrease in

mining activity. By the 1920s the mining and tourist lull that hastened the demise of the Gilpin and the Argentine Central now fell upon the C&S. With the advent of better roads many Clear Creek visitors began to arrive by automobile and bus. By 1926 the decline convinced the C&S to petition the Public Utilities Commission to abandon dedicated passenger service, a request that was granted in 1927.

The Great Depression hit hard on an already suffering Colorado & Southern Railway. The road managed to hang on through the early and mid-1930s, but by 1937 the financial situation had reached critical mass. In that year the old South Park trackage between Waterton and Climax was abandoned and the equipment transferred to the Clear Creek Branch where there was still some mining activity, although not enough to sustain the railroad. The Clear Creek line was abandoned in stages, the first included the famous Georgetown Loop and the "High Bridge." Deliberation continued throughout 1940 on the fate of the rest of the Clear Creek line. However, little could be done to keep the scrapper's torch at bay and the line rails were pulled up from Idaho Springs to Golden during the summer of 1941.

For many narrow-gauge railroads, abandonment meant consignment to the depths of time. However, a small portion of the C&S escaped such a fate. Tourism returned to the Clear Creek Valley in the 1950s. By 1968 the construction of a tourist railroad was being contemplated. Through the effort of the Colorado State Historical Society and many volunteers, two miles of the former Georgetown Loop were rebuilt including the famed "High Bridge." Today, visitors to the area can still board steam-powered trains and ride the Clear Creek narrow gauge.

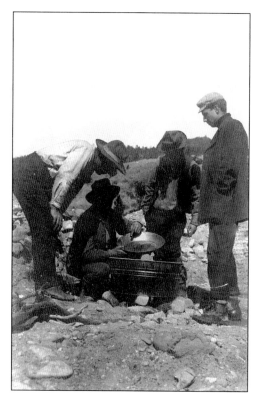

In the early 1860s hundreds of pioneers came to Clear Creek in the hopes of striking it rich. Miners like these turned the use of a sifting pan into an art while looking for that allusive gold nugget. Over time, mining processes became more refined and greater deposits of ore were discovered. From these discoveries came the need for economical transportation and the birth of the Colorado Central Railroad.

One

RUSH TO THE ROCKIES

In 1859 the West was in its infancy, a place where thousands journeyed in the hopes of establishing a new life. Many of these pioneers were lured by reports of gold being found in the Clear Creek District, a series of up and coming mining camps just west of an equally new Denver. The mining camps quickly took shape and soon the names of Black Hawk, Central City, Idaho Springs, and Georgetown were well known throughout the West. Along with the flood of hopeful prospectors came a supporting cast of bankers, merchants, and opportunists. With Denver as its logistical replenishment point, the mines and communities of Clear Creek prospered. Despite this good economic fortune, however, one lingering problem remained: The meager assortment of stagecoaches and freight wagons that now served the district were inadequate to handle the increasing volumes of people and freight. During the mid-1860s, several paper railroads had been contemplated, but it would take the combined efforts of William H.A. Loveland, Henry Teller, and Edward Berthoud to form the Colorado Central Railway and give the Clear Creek District its first viable railroad.

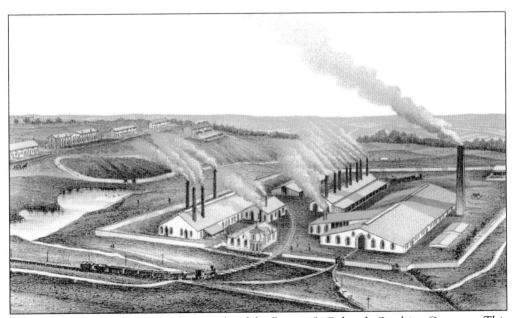

This early engraving shows the Argo works of the Boston & Colorado Smelting Company. This Denver-area reduction facility and others nearby had and abundance of flat land, coal, labor, and water; resources that were not always available in Clear Creek. Reduction works like this one would become a viable traffic point for early railroads.

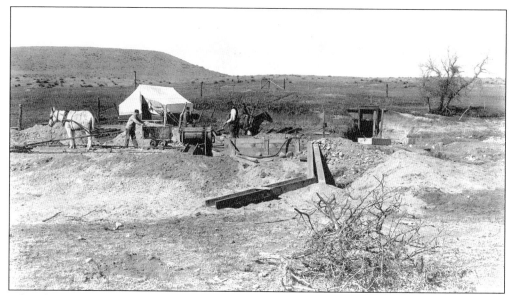

After the discovery of gold near Black Hawk, Central City, and Idaho Springs, the Clear Creek Mining District became choked with miners and claims. As a result, some fortune seekers elected to concentrate their efforts in other areas. This photo shows miners digging in the foothills west of Denver.

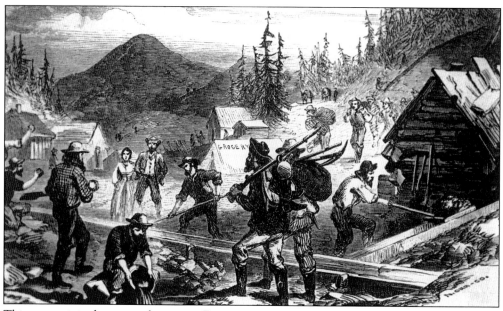

This romanticized view was how some Eastern artists envisioned the Clear Creek mining camps in the 1860s. While the depiction of the lone wife, canvas-roofed grocer, and "greenhorns" arriving with all of their worldly possessions on their backs are indeed realistic, these camps were not always the tranquil settings depicted in this engraving.

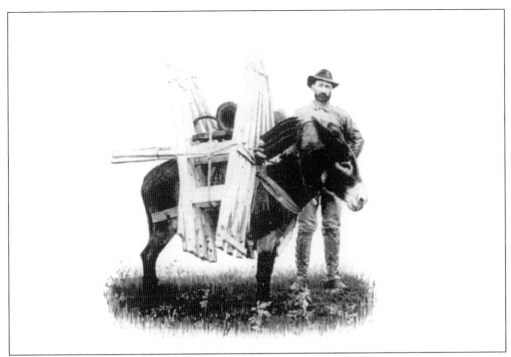

Known as Rocky Mountain Canaries and by several other less endearing names, burros were used to ferry lumber, hardware, and other supplies into the budding communities along Clear Creek. Their strength and ability to negotiate narrow mountain trails, even at high altitudes, made burros ideal for working in mining camps.

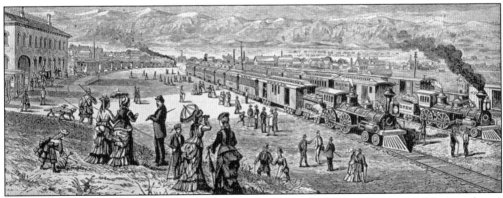

As interest in Colorado grew, so did investment opportunities. Throughout the 1860s, merchants and capitalists dreamed of making Denver a main stop on the Union Pacific's intercontinental railroad. While Denver's attempt to lure the Union Pacific failed, it did become the focal point of several other railroads. This 1870s engraving depicts a busy scene at Denver's first "union" station with a Colorado Central train in the background.

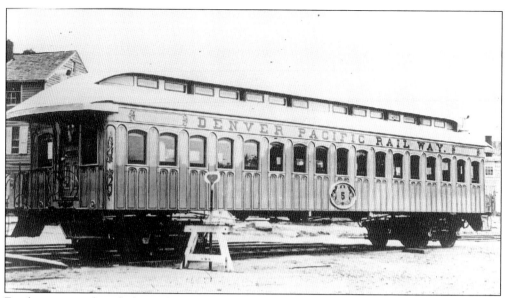

Finely appointed with brass fixtures and exotic woods, railroads took great pride in the construction and servicing of their passenger cars. Coaches like Denver Pacific No. 5 were used by some passengers connecting to the Colorado Central from Cheyenne.

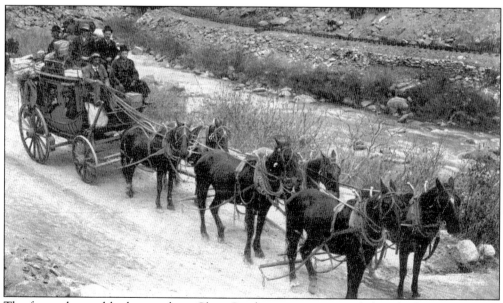

The footpaths used by burros along Clear Creek were soon expanded to facilitate the use of stagecoaches and freight wagons. Where possible, portions of these wagon roads were purchased to build the Colorado Central. As this scene demonstrates, some areas of the canyon were wide enough for both modes of transportation.

In their earliest stages of development, mining camps along Clear Creek were little more than a collection of tents. As time progressed, and if the diggings proved profitable, the tents would give way to more permanent structures such as cabins and rough-hewn buildings. In the foreground of this typical mining camp photo, the burro brigade has arrived bringing lumber and other supplies.

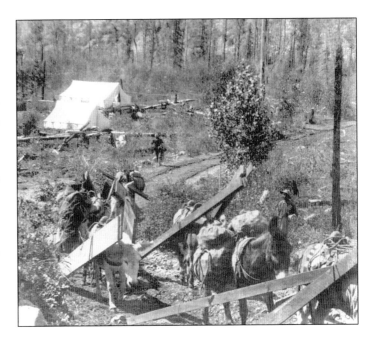

Established about the same time as Denver, the town of Golden would play a large roll in the development of the Clear Creek District. The town served as a supply base for many of the mines and communities along Clear Creek. Golden also had several small mills and collieries and was a large revenue generator for the Colorado Central.

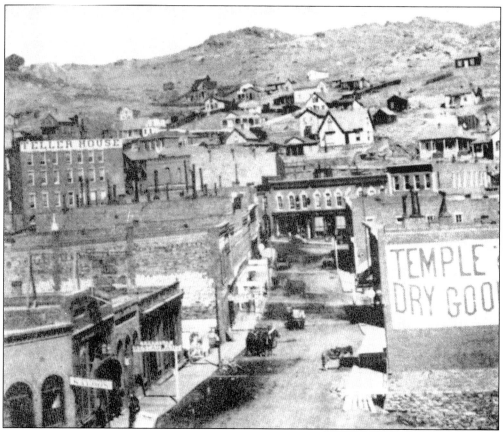

Central City was one of the first towns to develop in the Clear Creek District. The mines around the town provided outbound traffic for the smelters and mills to the east. The business district of Central City provided local residents with many of the same goods that could be found in Denver. The shelves of local merchants were kept full with inbound shipments carried over the Colorado Central. (Charles Weitfle photo.)

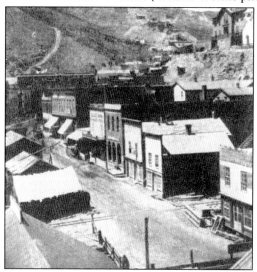

The town of Black Hawk grew out of the gulches where Clear Creek gold was first discovered. Although miners quickly adapted to the rugged terrain, the steep elevations around Black Hawk presented a problem for any potential railroad. In this late-1870s photograph, a Colorado Central train works its way along the elevated right-of-way through the Black Hawk business district. (Charles Weitfle photo.)

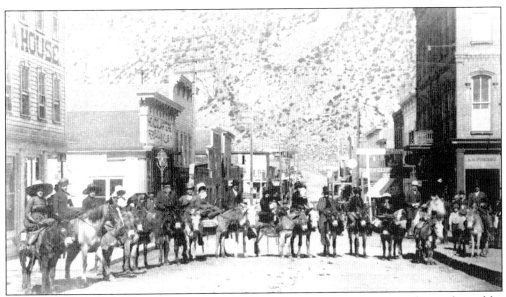

While burros played a prominent part in early Clear Creek mining, they were also used as public transportation for tourists. This busy Georgetown scene shows a group of tourists en route for some sightseeing. The opera house, the Republican Party Club, and the drug store of A.R. Forbes (right) can be seen in the background of this photo.

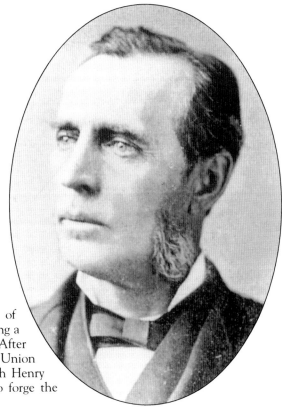

William A.H. Loveland was a man of vision who saw great potential in building a railroad into the Clear Creek District. After an unsuccessful attempt to bring the Union Pacific to Denver, Loveland, along with Henry Teller and Edward Berthoud, helped to forge the Colorado Central Railroad.

In the early 1860s this wide spot in Clear Creek was known as Idaho Bar. The name of the town was later changed to Idaho Springs and became a prominent shipping point on the Colorado

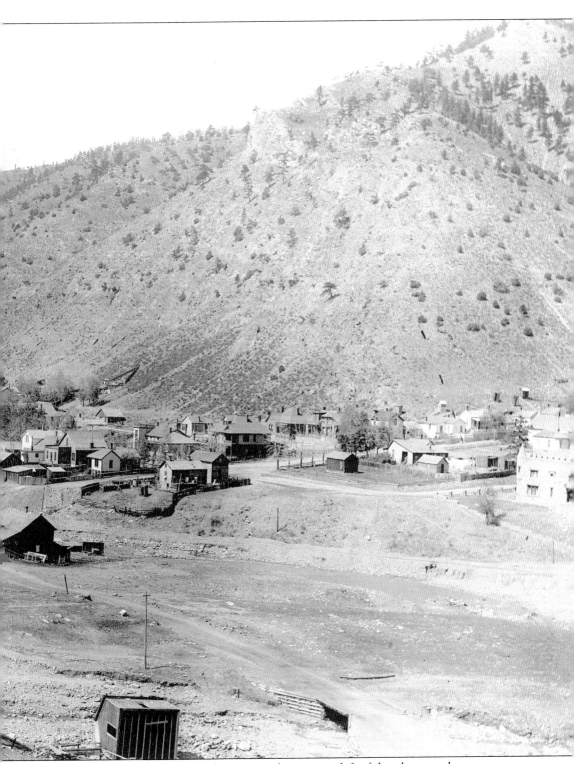

Central. The railroad facilities can be seen on the extreme left of the photograph.

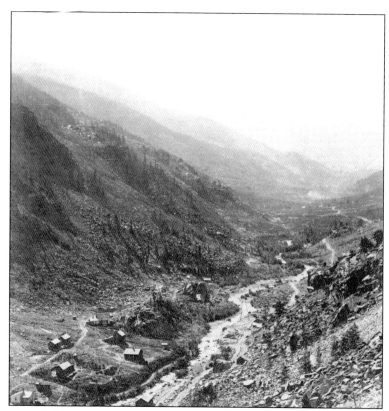

This is how the Clear Creek Valley appeared in the 1860s when many towns like Idaho Springs, Georgetown, and Central City were just beginning. The rut-filled wagon roads in this photo would soon be replaced by the rails of the Colorado Central.

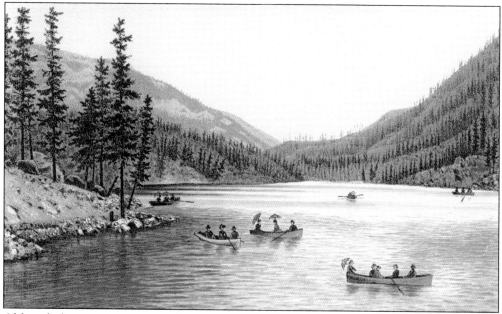

Although the rustic appearance of some Clear Creek communities could not be subdued, neither could the rugged beauty of the surrounding mountains. By the 1880s tourism had started to play a part in the local Clear Creek economy. This idealized engraving shows the "blue blood regatta," a group of visitors boating on Green Lake.

Two

RAILS TO THE MINES

The Colorado Central began operations in 1870 with a handful of diminutive locomotives traveling between Denver and Golden. Despite some hard economic times, the railroad was extended west of Golden along the banks of Clear Creek toward Idaho Springs. By the late 1870s the Colorado Central had pushed to Black Hawk and Georgetown, where rich ore deposits were being found. As the railroad continued to expand, its arrival brought about many changes in the communities along Clear Creek. Some of the small mills built to process local ore were now bypassed in favor of the larger mills near Denver. With its greater hauling capacity, the railroad provided an economical mode of transportation for the ore. Once emptied at Denver smelters, Colorado Central cars were again filled with coal and merchandise for the return trip to the mountains. Closing the loop on this transportation cycle, the Colorado Central played a key role in the local economy. Cheaper freight charges enabled mine owners to process lower-grade ores and the merchandise brought in on the return trip enabled local residents to procure most of their supplies without the expense of going to Denver.

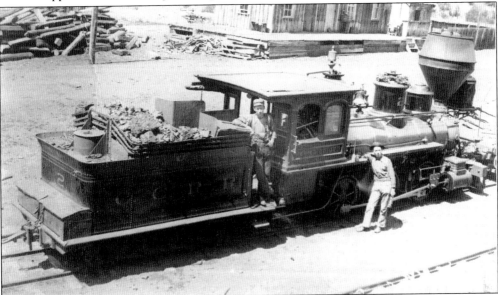

With tracks that were only three feet wide, the Colorado Central was smaller than a standard-gauge railroad, as were the locomotives used on the narrow gauge. This early 1880s view shows Colorado Central Engine No. 2 at Black Hawk. This engine was built in 1875 by the Porter-Bell Company. By this time the Union Pacific had gained control of the Colorado Central as evidenced by the "U" stenciled on the lip of the tender.

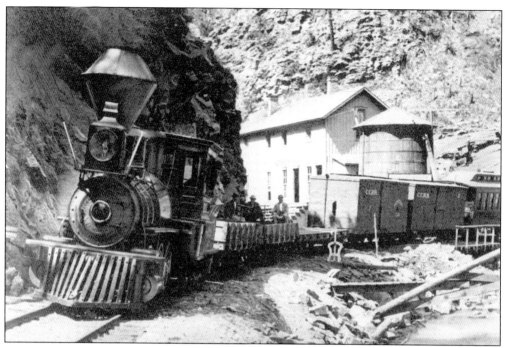

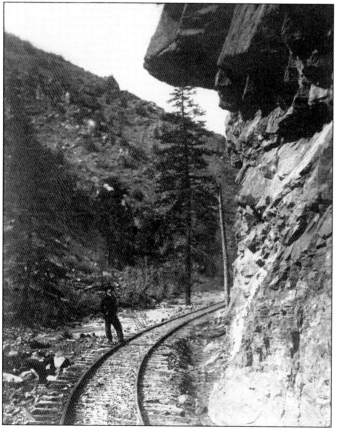

The narrow nature of Clear Creek Canyon was evident at Beaver Brook, where the Colorado Central was limited by geography when laying out its facilities. In this photo, one of the Colorado Central's Porter-Bell engines waits with a mixed train. (Charles Weitfle photo.)

Images of Hanging Rock were frequently used by the Colorado Central to capture the rugged scenery along its right-of-way. The rough-hewn ties and informal telegraph pole indicate that this photo was taken in the years soon after construction. (William Henry Jackson photo.)

This early view shows a Colorado Central engine and three passenger cars on High Trestle Bridge between Black Hawk and Central City. A portion of the town of Black Hawk can be seen between the trestle supports. (Joseph Collier photo.)

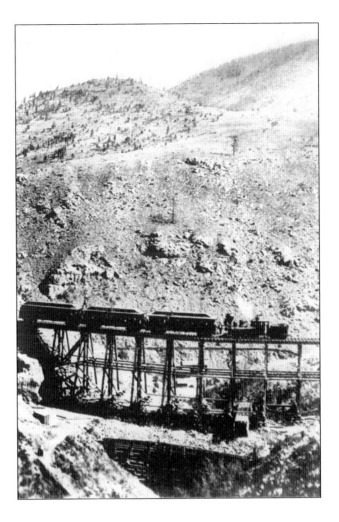

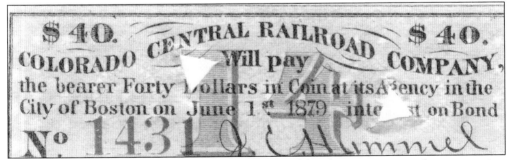

Like many other railroads, the Colorado Central issued bonds to raise money for construction and equipment and to make improvements. This Colorado Central bond coupon was cashed in for interest due in 1879.

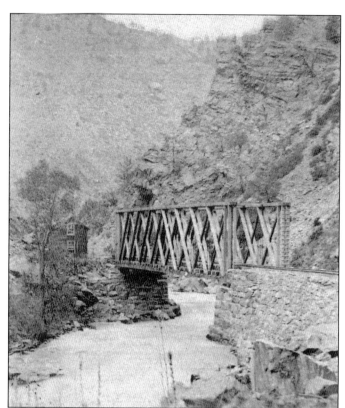

In its journey west from Denver, the Colorado Central crossed Clear Creek a number of times. One of these crossings was a bridge at Huntsman Ranch near milepost 20.6. The building in the background is a section house. (Joseph Collier photo.)

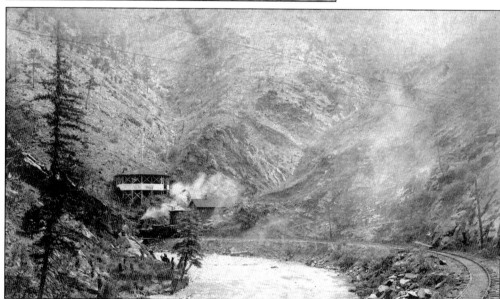

Beaver Brook was a popular destination with early Colorado Central passengers. The railroad facilities here included a depot, water tank, section house, and a handcar shed. In this photo, Engine No. 60 pauses to take on water. The structure above the water tank is the dance pavilion. Excursion trains were run to Beaver Brook for picnics, nature walks, dancing, and concerts (Alex Martin photo.)

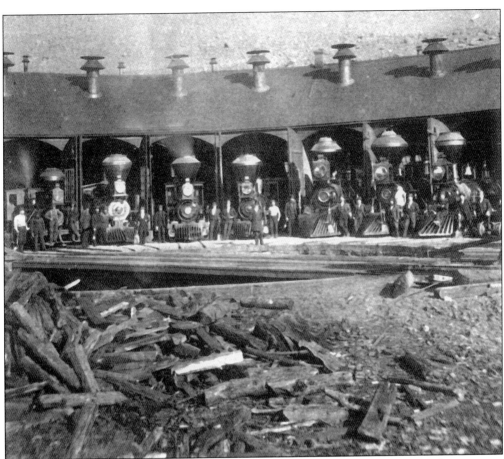

Early in its operations, the Colorado Central built a roundhouse at Golden. The Colorado Central added a third rail on its tracks between Denver and Golden in 1872 and the Golden roundhouse was used to house locomotives of both gauges. This unique 1870s view shows the contrast of the three Colorado Central standard-gauge engines on the right and the smaller narrow-gauge engines on the left.

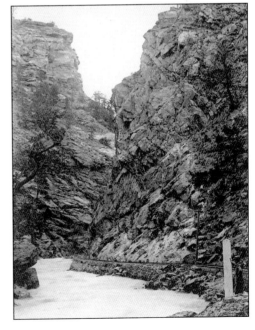

Eastern travelers aboard the Colorado Central were greatly impressed by Clear Creek's steep canyon walls and swiftly running water. This location was called Inspiration Point, a favorite stop for photographers and tourists. (William H. Jackson photo.)

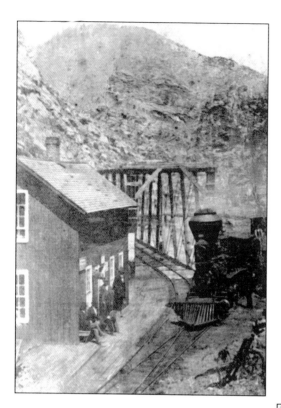

A popular gathering place for railroad employees and Colorado Central passengers was here at Fork's Creek. At this point both the railroad and the creek split, with one fork heading toward Black Hawk and Central City and the other to Idaho Springs and Georgetown. (Charles Weitfle photo.)

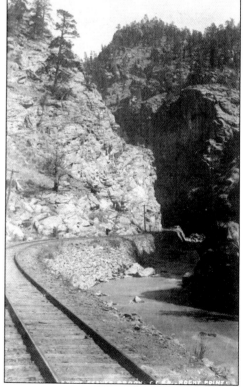

Rocky Point was just one of the many outcroppings that jutted out over Clear Creek and captured the interest of passengers. Noticeable in this photograph is the reinforced stone embankment designed to protect the roadbed from rising water levels. (Kilburn brothers photo.)

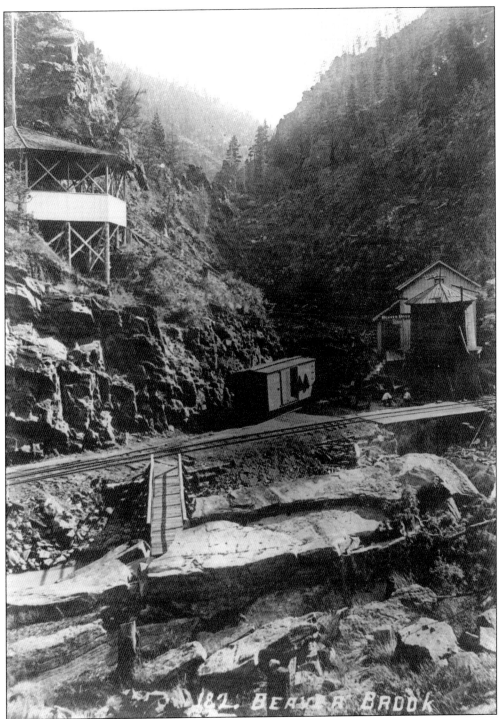

Beaver Brook was popular with passengers but as this rare image suggests, it was also a destination for freight too. In this photograph, a Colorado Central boxcar and gondola sit on the Beaver Brook siding. To the right is the water tank and depot while a portion of the elevated dance pavilion is visible on the left. (Alex Martin photo.)

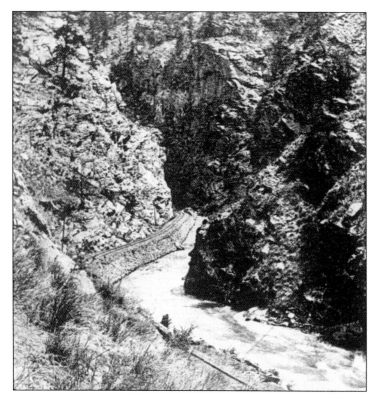

An unknown photographer worked hard to take this dramatic photograph. Railroads like the Colorado Central would often hire professional photographers to take images of the more scenic areas along the right-of-way.

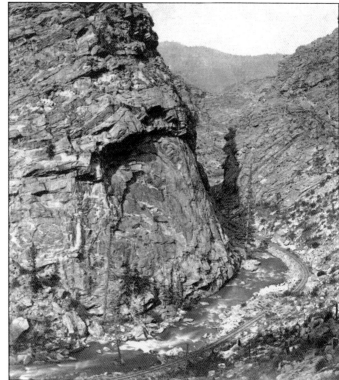

Shown here is another spectacular view of Clear Creek and the tracks of the Colorado Central. The tree stumps in the foreground indicate that some of the surrounding timber had been thinned, possibly for telegraph poles and building materials.

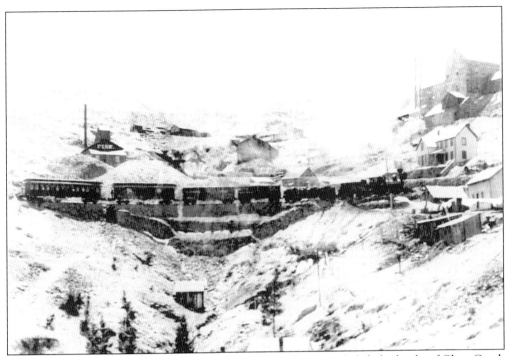

On the branch to Black Hawk and Central City, the railroad grade left the banks of Clear Creek and began to gain elevation. This photo shows a mixed train passing the Fisk Mine and illustrates the fact that neither the mines nor the railroads allowed altitude to inhibit prosperity.

Freight receipts such as this one are now prized by railroad paper collectors and provide unique insight as to how freight was shipped to the Clear Creek District. The freight was shipped in Colorado Central Boxcar No. 4. It is interesting to see that in 1877 it cost 50¢ to ship 80 pounds of freight from Denver to Floyd Hill.

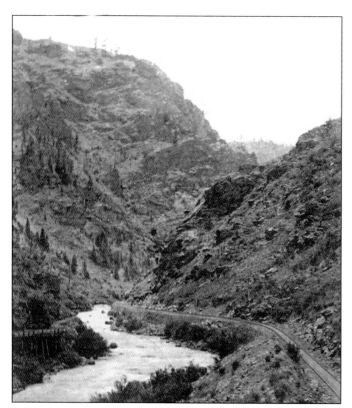

Taken at a wide spot near Floyd Hill, this photo shows the tracks of the Colorado Central as well as the wagon road to Idaho Springs in the lower left corner.

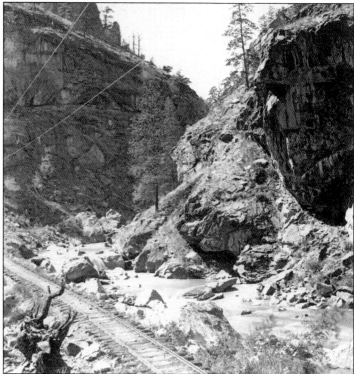

To the passing tourist, many of the rock formations along Clear Creek took animated forms. The rock on the right of this photograph has been referred to in some accounts as "The Old Smiling Man."

The crew of this narrow-gauge freight train stopped to have their photo taken near Beaver Brook sometime during the late 1870s. Colorado Central Engine No. 5, a 0-6-0 locomotive built by Porter-Bell in 1873, is at the head of the train. (Byron H. Gurnsey photo.)

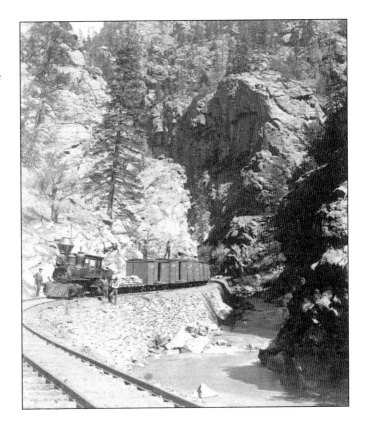

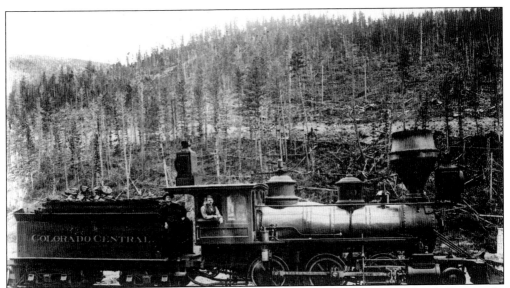

Colorado Central engines were not just relegated to the rails of the Clear Creek District. In this photo taken at Sunset, Colorado, Engine No. 10 does a turn on another Union Pacific subsidiary, the Greeley, Salt Lake & Pacific.

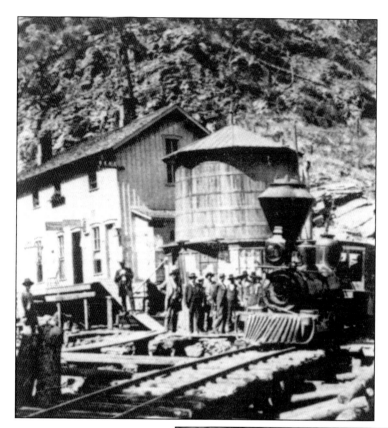

The ever-popular Beaver Brook depot formed the backdrop for this typical early narrow-gauge scene. In this Alex Martin photograph a group of men stand near the depot as one of the Porter-Bell engines fills up at the water tank. (Alex Martin photo.)

As the Colorado Central headed west from Fork's Creek, the Clear Creek Valley opened up to reveal some of the mines and communities that had helped to bring the district to prominence. In this photo, a Colorado Central passenger train has stopped near Georgetown below a series of mines known as The Amanda Group.

Three

UNION PACIFIC TAKES CONTROL

After a brief hiatus, William Loveland returned to the Colorado Central in 1879, later leasing it to the Union Pacific. The UP envisioned using the Colorado Central and the newly formed Georgetown, Breckenridge & Leadville Railway to reach the new mines of Leadville. Although economics favored this projection, geography did not. The heights above Georgetown proved a formidable obstacle and in an effort to gain the necessary altitude, contractors built a winding piece of right-of-way that became an engineering marvel. Grading of the line began in 1882 and ended in January 1884. "The Loop" as it was soon called, was an immediate tourist attraction. However, it had taken far too long to complete and the GB&L was still many miles from Leadville. In 1884 the arrival of the Denver, South Park & Pacific in Leadville made any further construction on the GB&L unnecessary. Throughout the late 1880s, the Colorado Central continued to haul ore and tourists and while the balance sheet was not a barnburner, its returns managed to keep the creditors at a distance.

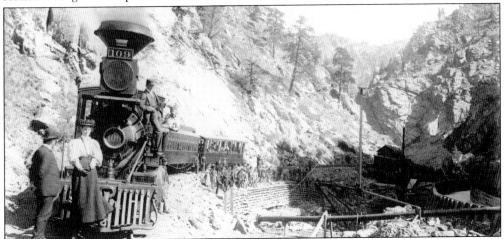

When the Union Pacific and later the Union Pacific, Denver & Gulf absorbed the former Colorado Central narrow gauge, it inherited one of the most beautiful right-of-ways in Colorado. Heavily patronized during the tourist season, the UPD&G added open cars to its trains in an effort to afford passengers a better view of the scenery. This photo was taken near milepost 26.7 at Roscoe. Although the cars on this passenger train are from the UPD&G, Engine No. 109 bears the markings of the Denver, Leadville & Gunnison. The DL&G was the Union Pacific subsidiary that absorbed the Denver, South Park & Pacific. (Harry H. Buckwalter photo.)

TO GOLDEN, CENTRAL, GEORGETOWN AND LEADVILLE.

UNION PACIFIC RAILWAY---COLORADO DIVISION.

Time Table of Passenger and Freight Trains between Denver and Golden, Central and Georgetown, and Accom'n between Denver and Longmont.

WESTWARD / STATIONS / EASTWARD — Broad Gauge

No. 7 Freight	No. 5 Freight	No. 3 Pass'gr	No. 1 Pass&M	Broad Gauge	Dist. from Denver	No. 2 Pass&M	No. 4 Pass'gr	No. 6 Freight
8.10PM	4.00PM	7.30AM	Lv Denver Ar	9.10AM	10.50AM	7.55PM
8.18		4.08	7.38 Argo	2	9.03	10.42	7.45
8.48		4.25	7.52 Arvada	8	8.48	10 25	7.25
9.25PM		4.50PM	8.16AM	Lv Golden Ar	15	8.25AM	10.00AM	6.55

WESTWARD / STATIONS / EASTWARD — Narrow Gauge

No. 19 Freight	No. 17 Pass'gr	No. 15 Pass'gr	No. 13 Pass&M	No. 11 Pass&M	Narrow Gauge	Dist. from Denver	No. 12 Pass'gr	No. 14 Pass'gr	No. 16 Pass&M	No. 18 Pass&M	No. 20 Freight
6.45AM	5.00PM	4.55PM	8.40AM	8.35AM	Lv Golden Ar	9.50AM	9.55AM	6.45PM	6.50PM	12.25AM
7.05	5.20	5.15	9.00	8.55 Chimney Gulch	18	9.35	9.40	6 25	6.32	12.10
7.25	5.40	5.35	9.25	9.20 Guy Gulch	21	9 20	9.25	6.10	6.16	11.55
7.35	5.50	5.45	9.36	9.32 Beaver Brook	22	9.06	9.10	6.02	6.08	11.45
7.43	6.02	5.57	9.42	9.38 Elk Creek	23	9.00	9.05	5.57	6.02	11.38
8.00	6.20	6.15	10.02	9.56 Big Hill	26	8.45	8.50	5.35	5.40	11.20
8.08	6.30PM	6.25	10.12	10.07AM Forks Creek....	28	8.38AM	8.40	5.28	5.32PM	11.12
8.25		6.40	10.28	 Cottonwood	30	8.25		5.15		11.00
8.50		6.55	10.45	 Smith Hill	32	8.10		5.00		10.45
9.10AM		7.15	11.10	 Black Hawk	35	7 50		4.40		10.25AM
		7.45PM	11.40AM		Ar .Central City .Lv	39	7.20AM		4.10PM		

No. 19 Freight	No. 17 Pass'gr	No. 15 Pass'gr	No. 13 Pass&M	No. 11 Pass&M	Station	Dist. from Denver	No. 12 Pass'gr	No. 14 Pass'gr	No. 16 Pass&M	No. 18 Pass&M	No. 20 Freight
	6.30AM			10.10AM	Lv .Forks Creek .Ar	28	8 38AM				5.28PM
	6.50			10.25 Floyd Hill	31	8.20				5 05
	7.20			10.55 Idaho Springs	36	7.55				4.35
	7.32			11.08 Fall River	38	7.42				4.22
	7.50			11.26 Mill City	42	7.25				4.05
	8.00			11.38 Lawson	44	7.12				3.52
	8.06			11.45AM Empire	45	7.05				3.45
	8.30PM			12.10PM	Ar .Georgetown .Lv	50	6.45AM				3.25PM

ADDITIONAL TRAINS. STAGE LINES, Etc.

Train No. 21 leaves Golden at 2.00 p.m., Beaver Brook 2.50, Forks Creek 3.22, and arrives at Black Hawk at 4.15.

Train No. 22 leaves Black Hawk at 5.40 p.m., Forks Creek 6.30, Beaver Brook 7.05, and arrives at Golden at 7.50.

Trains 1, 2, 7, 11, 13, 16 and 18 run daily; Train 6, daily between Golden and Denver; other trains run daily except Sunday.

For Kokomo, Ten-Mile, Breckenridge and Leadville.—S. W. Nott's double daily line of Concord coaches connects with passenger trains at Georgetown, for Silver Plume, Brownsville, Bakersville, Kokomo, Decatur, Breckenridge, Carbonateville, Ten-Mile, and Leadville.

For Middle Park.—During the tourist season, stages of the Middle Park & Bear River Mail and Express Company leave Georgetown Tuesdays, Thursdays and Saturdays, at 7.00 a.m., for Hot Sulphur Springs, Middle Park, returning on alternate days.

For Estes Park.—During the tourist season, stages of the Longmont & Estes Park Line leave Longmont on arrival of the morning express from Denver (see time card on another page) daily except Sunday, reaching Estes Park same afternoon. Returning, stages leave Estes Park in the morning, connect with southbound express at Longmont, and reach Denver same evening.

For North Park.—Stages will leave Fort Collins, upon the arrival of the morning express, for Mason City and other North Park points.

This timetable from April 1880 shows the consolidation efforts of Jay Gould's railroad empire with the Colorado Central being referred to as the Colorado Division of the Union Pacific. The schedule shows 17 trains daily with nine going west and eight heading east. At this time the fare from Denver to Georgetown was $4.30, and $3.10 to Central City.

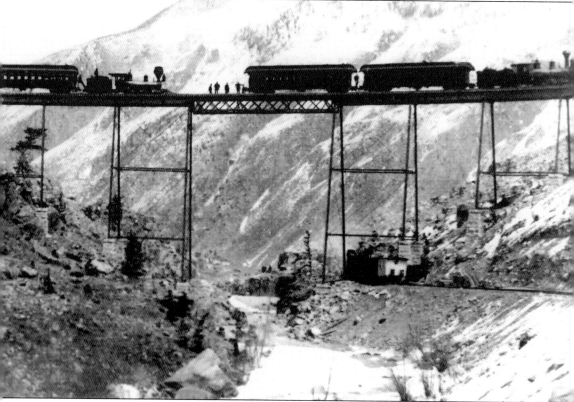

Snow still covers portions of the Clear Creek Valley in this early view of the Georgetown Loop. In this scene, two trains and their passengers look down upon a short freight train.

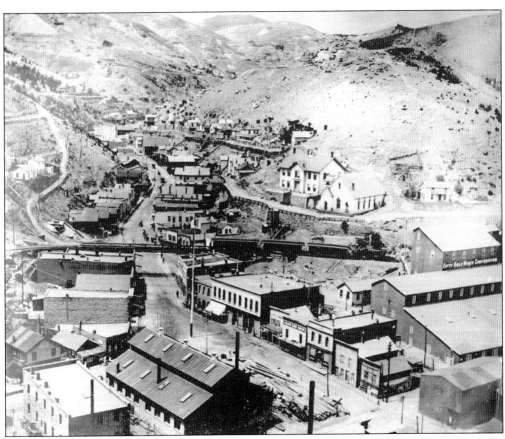

The initial construction of narrow-gauge tracks north from Fork's Creek ended at the already growing town of Black Hawk but the line was later extended to Central City in 1878. This mid-1880s photograph shows a Colorado Central train coming off the trestle that spanned Gregory Street. (Charles Weitfle photo.)

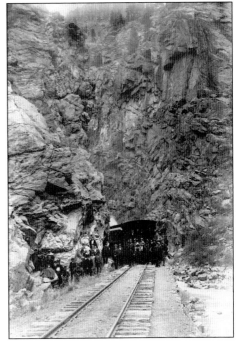

In this 1890s photo, the steep walls of Clear Creek Canyon dwarf the excursion car on the end of a UPD&G passenger train. It was not uncommon for church groups, businesses, and fraternal organizations to charter trains for summer picnics in the mountains and this image may depict such an outing. (Harry H. Buckwalter photo.)

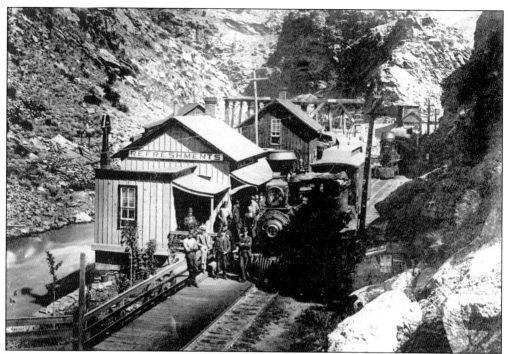

Headed by Engine No. 12, an eastbound train from Georgetown has just arrived at Fork's Creek. The locomotive stands besides the eating house while the trailing cars are in front of the depot. The eastbound train from Central City is in the background. (Charles Weitfle photo.)

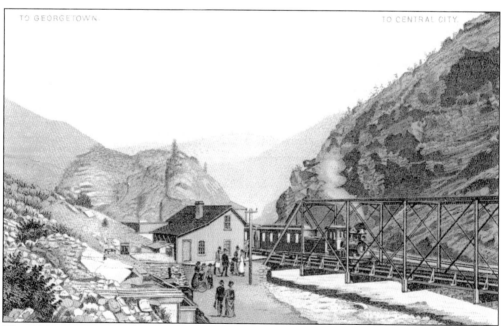

This 1880s engraving of Fork's Creek shows a train arriving from Georgetown. The tracks on the far side of the bridge continue to Black Hawk and Central City. The building to the left of the train is the Fork's Creek section house.

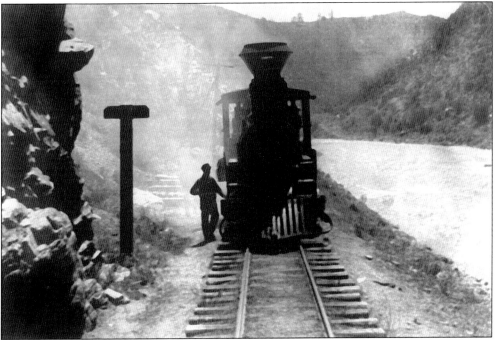

OFFICE OF THE BOSTON AND COLORADO SMELTING COMPANY,

ARGO, COLORADO, *August 2nd* 1881.

RECEIVED OF *Moore Mining & Sm. Co.*

THE LOTS OF ORE HEREIN DESCRIBED.

WEIGHT OF ORE			DESCRIPTION.	ASSAY PER TON			Price per Ton		VALUE		
Wet Weight		Dry Weight		Gold	Silver						
Tons	Lbs	Water	Tons	Lbs	Ounces	Ounces		Dolls.	Cts.	Dolls.	Cts.
9 676		*1 car matte 186 2ox*		281.	495	354	70	3312	18		
					To paid freight			9	35		
								3302	83		

H. R. Wolcott a. MANAGER.

This 1881 receipt from the Argo works of the Boston & Colorado Smelting Works shows the refined results of a carload of ore shipped from Moore Mining in Black Hawk. As in this case, some mines elected to have the freight taken out of the assay value of the ore.

Even though they were smaller than their standard-gauge counterparts, narrow-gauge steam engines still required a lot of care. This photo shows an engineer doing some routine oiling along one of Clear Creek's few straight tangents.

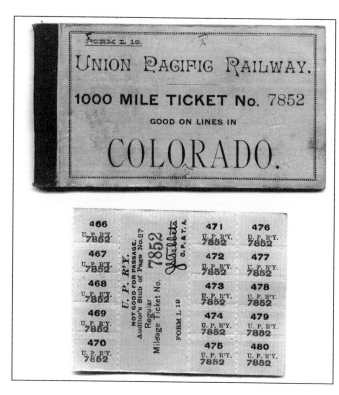

Narrow-gauge rails reached Georgetown in August 1877 and for the next seven years this was the western terminus of the Colorado Central. During this time Clear Creek merchants did a booming business, with much of the goods sold being brought in by the railroad. Smaller orders of merchandise were usually part of less-than-carload (LCL) shipments, such as the one listed on this 1880 Union Pacific receipt.

Railroad tickets took several forms. Some were issued between specific points; others had to be used before a certain time. This 1880s era commutation booklet contained mileage coupons good for 1,000 miles over the Union Pacific's Colorado Division. The bearer would use this like a regular ticket and present the booklet to a conductor or agent so that the appropriate number of coupons could be deducted.

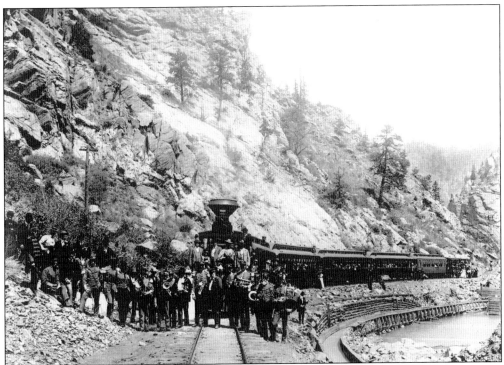

Roscoe was a popular stopping place for charter trips and excursions. In this photo, Engine No. 8 and a string of UPD&G cars has stopped for a photo opportunity. The group in this 1890s photo consists of the train crew, tourists, and what appears to be a mixture of fraternal bands. (Harry H. Buckwalter photo.)

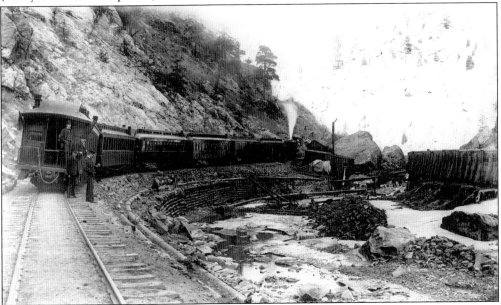

Another view of Roscoe shows this Union Pacific, Denver & Gulf train moving in the opposite direction. Ever vigilant at keeping his train on time, the conductor in this photo glances at his watch before getting underway. (Harry H. Buckwalter photo.)

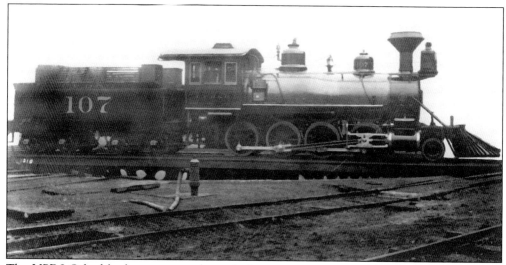

The UPD&G had both narrow- and standard-gauge operations and by the early 1890s, had become a repository for equipment swallowed up in several Union Pacific acquisitions. While the UPD&G had acquired many locomotives in these consolidations, it also purchased new ones like 2-8-0 No. 107. This standard-gauge engine was built in 1897 by the Baldwin Locomotive Company and later became Colorado & Southern No. 426.

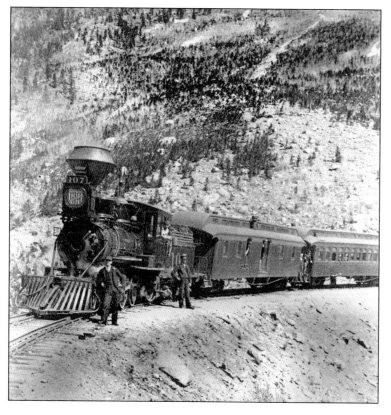

The lettering on the side of the locomotives and passenger cars in this photograph gives evidence that during the 1890s the Union Pacific afforded some autonomy to the DL&G and the UPD&G. However, the Union Pacific shield on the lens of Engine No. 107's headlight leaves little doubt about the parent company. This photographer not only captured the attention of the locomotive crew but also the mail clerk and baggage man.

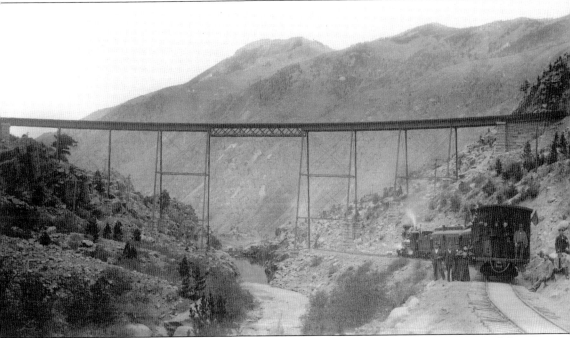

Almost immediately after its completion in 1884, the Georgetown Loop became one of the most identifiable features of Colorado railroading. For Eastern tourists, a trip to the "High Bridge" was a must.

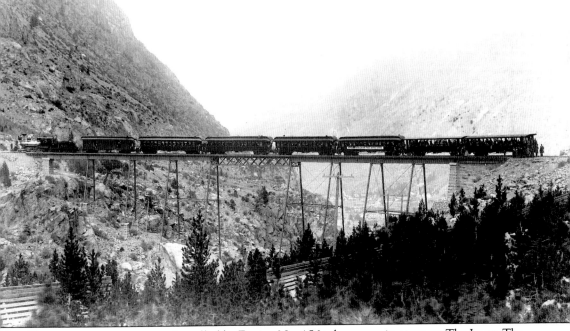

This seven-car passenger train pulled by Engine No. 156 takes a scenic pause on The Loop. The banner on one of the passenger cars indicates a charter for the National Association of Post Office Clerks. (Harry H. Buckwalter photo.)

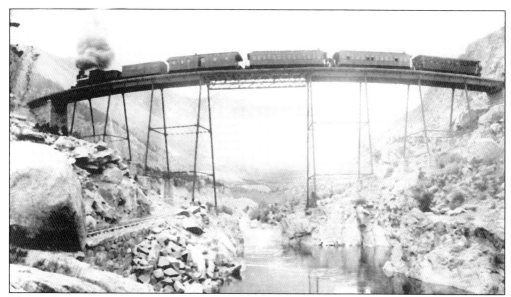

This early 1890s panoramic image of "High Bridge" captures equipment from three different Union Pacific subsidiaries. The engine is Denver, Leadville & Gunnison No. 116, followed by a Denver, South Park & Pacific boxcar, and a string of UPD&G coaches.

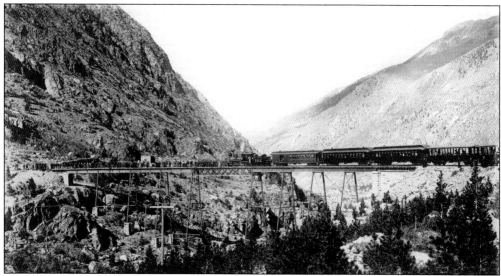

Using spare motive power from the South Park, DL&G Engine No. 162 poses on the "High Bridge" along with DL&G Combine No. 708 and a long line of UPD&G passenger cars including at least two open observation cars. During the summer months many passenger trains traversed The Loop at full capacity. This may explain the length of the train and the borrowed equipment. (Harry H. Buckwalter photo.)

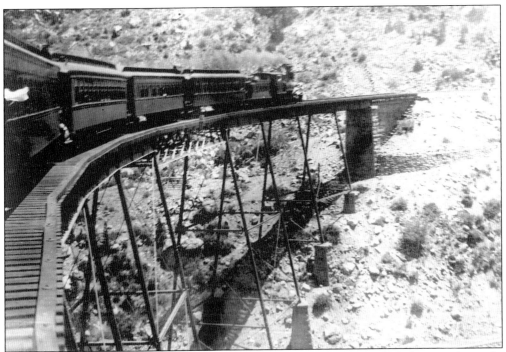

The wide sweeping curve made by the "High Bridge" allowed passengers to look down on the tracks below. Trains would sometimes stop here and allow passengers to get out and walk on the bridge.

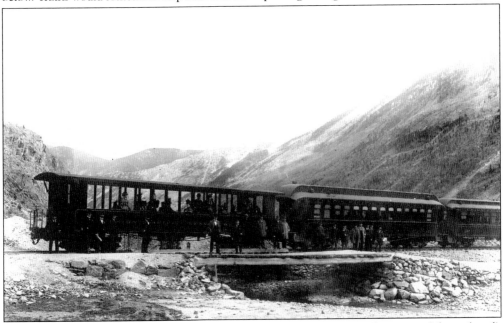

In this photo, one of the UPD&G's open observation cars has stopped on one of the railroad's many Clear Creek bridges. These cars were ideal for summer touring and were even employed during the more mild months of the spring and fall. The UPD&G had six of these cars numbered 192–198. The Union Pacific must have anticipated the tourism that accompanied the opening of the Georgetown Loop as some of the earliest cars were built in 1883.

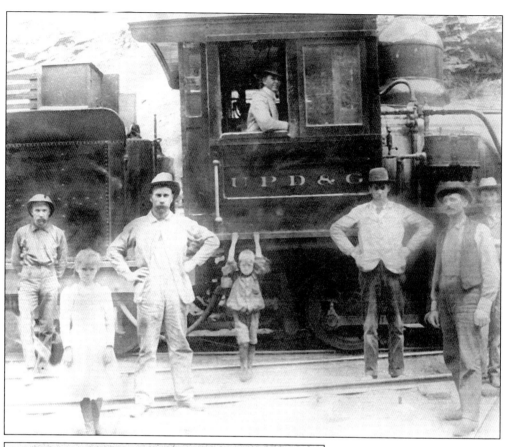

UNION PACIFIC, DENVER & GULF RY.
FRANK TRUMBULL, RECEIVER.

Round Trip Excursion.—Stub.
NOT GOOD FOR PASSAGE.

For........................(....1....) Person.....

SILVER PLUME

To.............. *Denver*

AND RETURN.

Account.............. *6690*

Issued.............. *Dec 25* ..189

Expires.............. *Jany 4* ..1898

1178 | Amount.............. *255*
Form R. T. Ex.

This photograph shows the proud crew of a UPD&G engine, possibly No. 150. The dapper-looking gentleman in the cab was probably a passenger who took advantage of the stop and had his photo taken with the engine.

In 1898 it cost $2.55 for the bearer of this ticket to ride from Silver Plume to Denver and back—the better part of a day's worth of wages for local miners. Owing to the expense of rail travel and the boom-bust lifestyle of some of the working class, it was not unusual for some passengers to purchase their tickets in advance.

Four

CLEAR CREEK COMMUNITIES

In early 1890 the Colorado Central, Georgetown, Breckenridge & Leadville, and several other Union Pacific subsidiaries merged to form the Union Pacific, Denver & Gulf Railway. A year earlier the Denver, South Park & Pacific had been reorganized as the Denver, Leadville & Gunnison. Now the two lines, keeping the same destinations but under new names, struggled to keep their financial balance. By this time the Clear Creek region was more than just a group of mines connected by a unified railroad, it was a mining district made up of unique towns. As the reach of the Colorado Central was extended, new tracks fostered new villages and stimulated some old ones. Georgetown, Idaho Springs, Black Hawk, and Central City were already well known but smaller towns like Dumont, Empire, and Lawson were destined to have an identity all their own. Together, they formed a series of communities and economic systems whose existence was predicated on mining and in which railroading served as the common denominator.

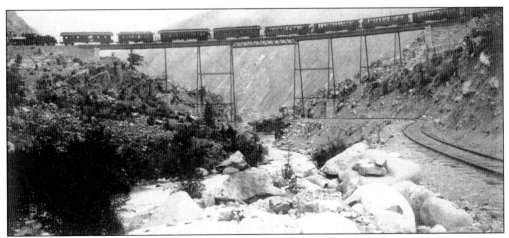

The railroad brought development and prosperity to the Clear Creek Mining District but also brought thousands of tourists. During the summer months, tourism proved to be a large part of the economy. The money generated from so many visitors was evident on the balance sheets of local merchants and provided revenue for civic improvements. With at least eight coaches and a baggage car, this photo shows an unusually long tourist train taking up the entire span of the "High Bridge."(William H. Jackson photo.)

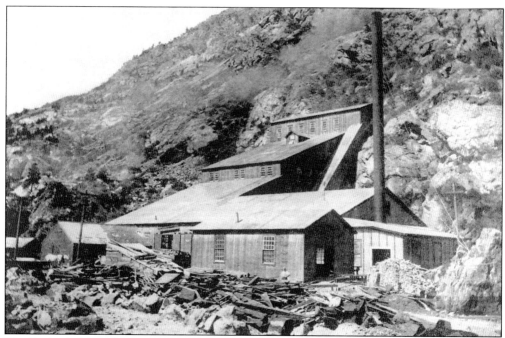

The Burleigh Mill, shown in this photo, was located near Silver Plume and provided work for local miners. Owing to its close proximity to some of the area mines, the Burleigh also proved to be a cost effective reduction alternative for mine owners (George Dalgleish photo.)

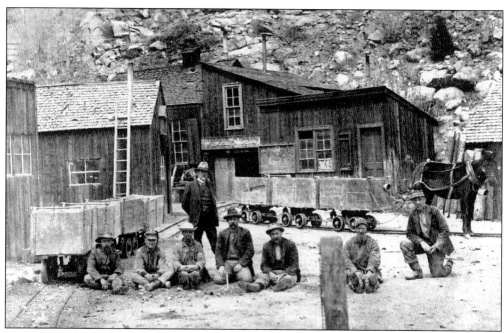

This photo shows the Diamond Tunnel of the Corry Mining Company. The Corry Group comprised over 30 claims on 130 acres. The man standing in this photograph is believed to be C.S. Desch, manager and owner of the Diamond claim (George Dalgleish photo.)

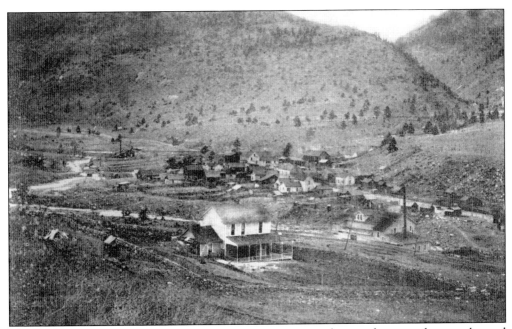

One of the smaller towns along Clear Creek, Dumont was a supply point for mines that were located deeper in the mountains. Provisions were off-loaded at Dumont where they were transferred to wagons and delivered to places like Alice and Yankee Hill. The town was originally known as Mill City but the name was changed to Dumont in 1880. (George Dalgleish photo.)

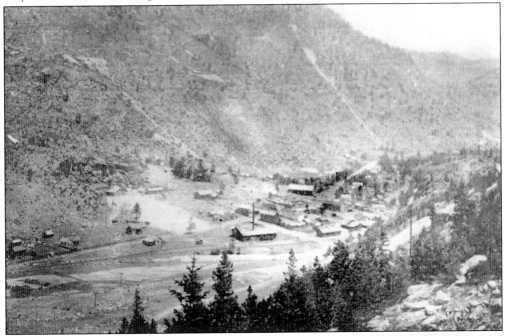

Founded in 1877, Lawson was similar in composition to Dumont and served as the commercial and residential hub for some of the surrounding mines. Although few in number, local businesses like Bennet's Saloon and A.F. Anderson Mercantile owed their existence to the mines and catered to the working class. (George Dalgleish photo.)

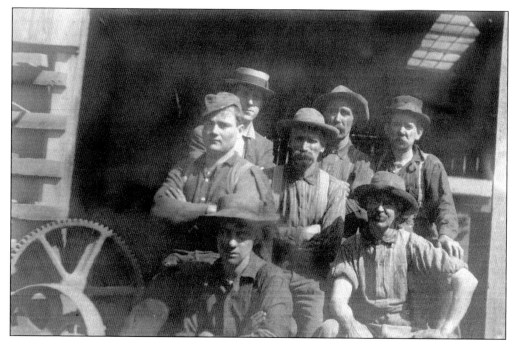

By the end of the 1890s technological advancements in mining saw the use of machinery in both the mining and reclamation processes. Men like these Idaho Springs blacksmiths helped to keep the mines and their equipment running.

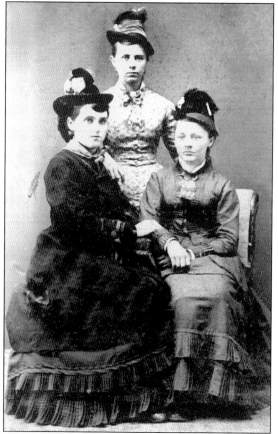

Despite the sometimes harsh climate and the demanding nature of the work, the Clear Creek District was a place where both men and women could find prosperity. Margaret Henry (left) arrived in Idaho Springs in the 1880s. She had followed her husband from Iowa who had hoped to make enough money in mining to send for the rest of her family. When her husband died, Margaret used her small inheritance to open a clothing shop, which sisters Olive (center) and Elizabeth (right) helped to run. (Carol Baylor collection.)

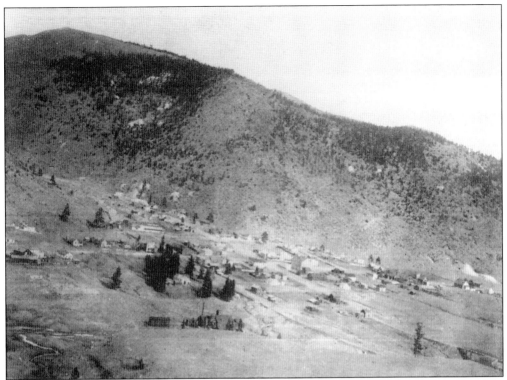

By 1900 nearly 500 people were calling Empire home. The town was first known as Empire City but by 1886 the name had been shortened. New advances in mining technology during the 1890s helped some of the area's marginal mines turn a profit. (George Dalgleish photo.)

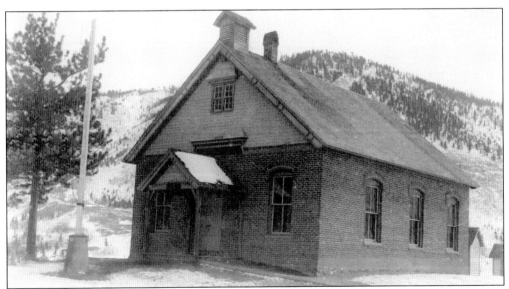

With a flagpole out front and an outhouse in the rear, this little brick schoolhouse served the children of Empire. Although the schools of many Colorado mining towns were hastily built, it appears the founding fathers of Empire gave their school a little more consideration. (George Dalgleish photo.)

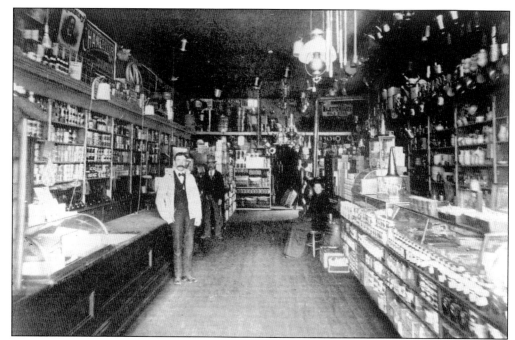

A vast array of canned goods and hardware awaited the customer who walked into the Roberts Brothers Mercantile in Silver Plume. Catering to tourists and miners, the inventory consisted of groceries, sundries, tools, and lumber. This was a branch office for the Roberts Brothers with the main store being in Idaho Springs. (George Dalgleish photo.)

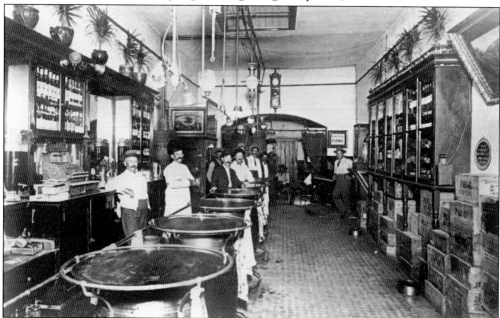

One old mining camp joke told of how the rich learned the art of mining in college while the poor learned it in saloons. Whatever their educational value, bars like this one were a prominent part of mining life. After a long shift in "the hole," many miners hit the "Entertainment District" anxious to quench their thirst.

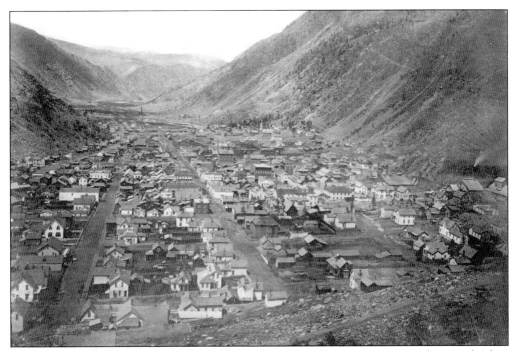

This photograph, looking down from the heights above Georgetown, was taken in the late 1870s soon after the rails of the Colorado Central had arrived, and demonstrates how much the area had developed, even at this early stage. (Charles Weitfle photo.)

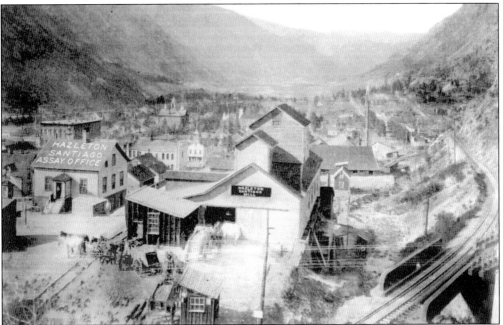

Although many of their claims were near Silver Plume, the mill and assay offices of the Hazelton-Santiago Group were in Georgetown. The mill shown in this photo had a capacity of 50 tons per day. In the background is the ornate bell tower of the Georgetown Public School. (George Dalgleish photo.)

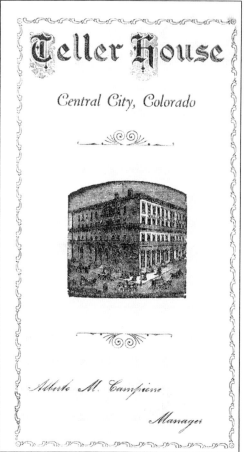

Teller House

Central City, Colorado

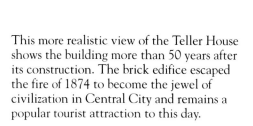

Alberto M. Campione

Manager

At the time it was built in 1872, Central City's Teller House was reputed to be "the finest hotel west of the Mississippi" and while many establishments claimed that honor, the charms of the Teller House were enough to inspire a visit from President Ulysses S. Grant. The engraving on this Teller House advertising handbill depicts a busy scene of horses, carriages, and hotel guests.

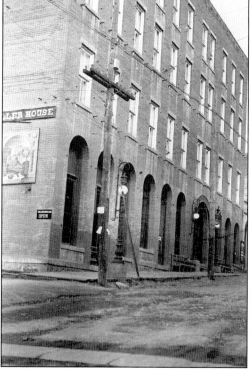

This more realistic view of the Teller House shows the building more than 50 years after its construction. The brick edifice escaped the fire of 1874 to become the jewel of civilization in Central City and remains a popular tourist attraction to this day.

The riches of the Clear Creek District attracted many notable people. One such figure was William Frederick Cody. Shown in this photo wearing a suit rather than the buckskin garb that made him an institution, "Buffalo Bill" and his "Scouts of the Plains" appeared in both Central City and Georgetown with the Colorado Central providing the transportation for the theater troupe.

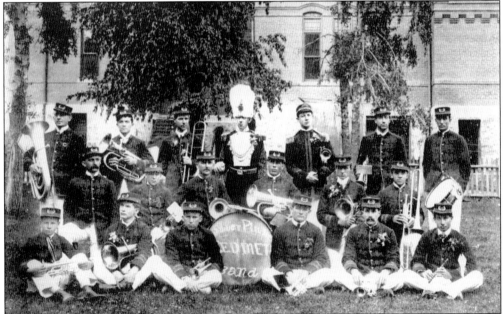

Bands were another source of Clear Creek entertainment. Some of these groups, like the Silver Plume Band shown in this photo, were not professional musicians but musically inclined miners and merchants who played at local picnics, parades, and other civic functions. W.J. Guard, shown in this photo wearing the white hat of a band leader, was also the owner of a local dry goods store and a former mayor of Silver Plume. (George Dalgleish photo.)

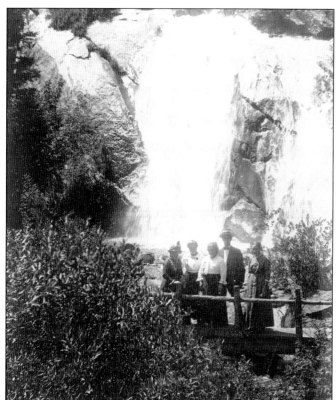

It was not just the scenic wonder of The Loop that brought tourist to Georgetown. Several waterfalls in the Clear Creek area also attracted visitors. The trains ran often enough that tourists arriving on the morning train could take in many of the sights, have lunch, and then leave on the afternoon train.

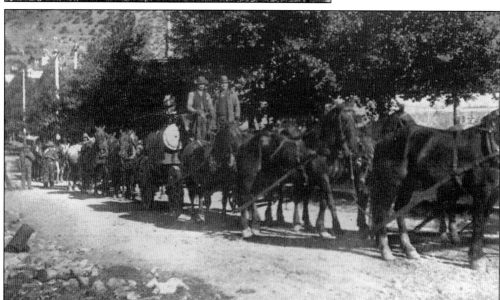

Not all Clear Creek freight was moved by the railroad. Some mines and settlements were located on the ridges and valleys to the north and south of Clear Creek and were not accessible by rail. Serving these communities were outfits like this freight team belonging to C.H. Dyer. Dyer's freight wagons were a common sight around Silver Plume and other towns in the western part of the district.

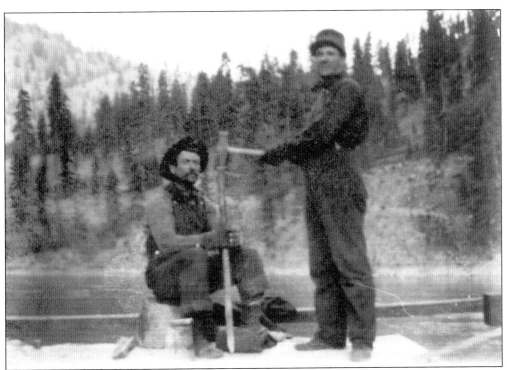

Before the age of mechanical refrigeration, merchants and shippers used ice to keep perishables from spoiling. Some of this ice was harvested from lakes during the winter and kept in icehouses until needed. The two men in this photo are cutting ice on a lake near Georgetown.

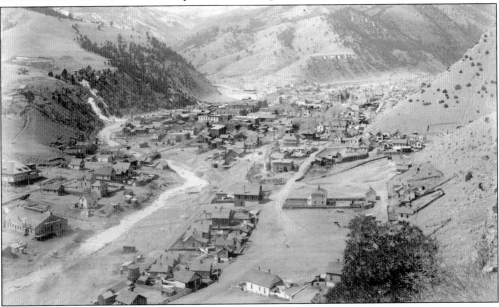

Idaho Springs was one of Clear Creek's more populated towns. In this 1890s photo, a wagon road veers off to the right while the railroad tracks hug the edge of Clear Creek and then curve their way into the main business district. It is of interest to note the odd shaped water tank in the lower left-hand corner.

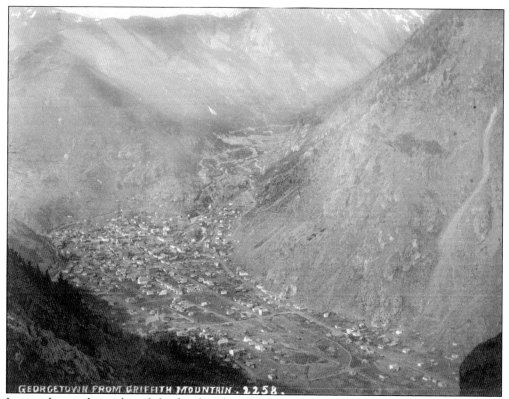

GEORGETOWN FROM GRIFFITH MOUNTAIN. 2258.

It must have taken a long hike for the photographer, presumably William Henry Jackson, to position himself to take this photograph. The image looks down on Georgetown from the heights of Griffith Mountain—a fitting tribute to George Griffith, the man for whom the town and the mountain were named.

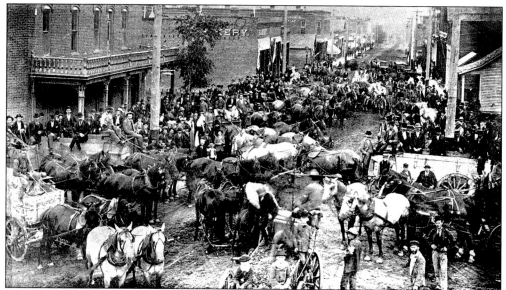

The presence of a railroad in the Clear Creek District did not always facilitate a decline in other modes of transportation. Idaho Springs was the setting for this 1893 horse-drawn traffic jam.

Five

THE GILPIN TRAMWAY

Clear Creek was home to several different railroads, including the Gilpin Tramway, a two-foot-gauge railroad whose construction began in 1886 and was completed in 1888. Not really a direct route to anywhere, the Gilpin consisted of a maze of tracks that blanketed the mines and hillsides around Black Hawk and Central City. Its main purpose was to carry ore from nearby mines to the mills around Black Hawk. A step above wagon freighting and without the expense of a larger railroad, the tiny Shay locomotives and gondolas served many local mines and became a curiosity with the many visitors who had begun to visit the area.

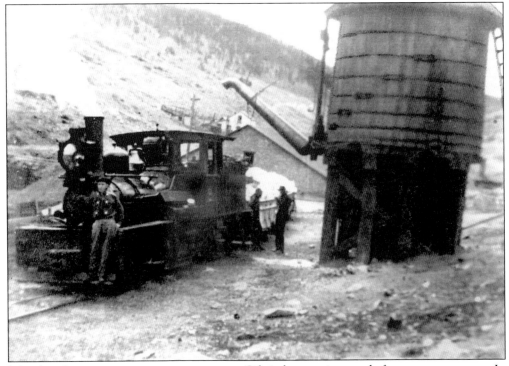

Like their larger narrow-gauge counterparts, Gilpin locomotives made frequent water stops. In this photo, one employee stands on the pilot of a Shay while two others engage in conversation while topping off the engine.

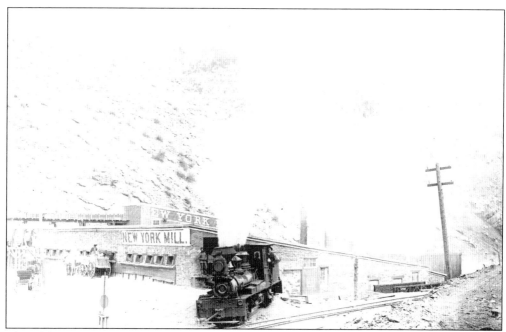

The addition of a third rail was usually something associated with the combination of narrow and standard-gauge operations. However, this photo shows the three-rail trackage around the New York Mill which incorporated the two-foot-gauge Gilpin Tramway and the three-foot-gauge UPD&G, later the Colorado & Southern Railway.

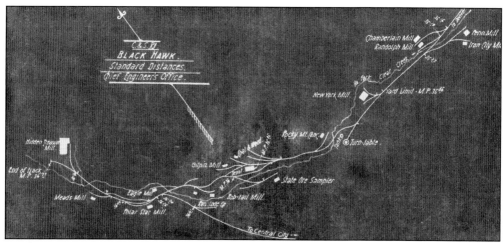

At the onset of construction, both the Gilpin and the Colorado Central were challenged by the local geography. This 1904 Colorado & Southern map shows the labyrinth of track, mines, and mills around Black Hawk as well as the turntable and water tank located near the New York Mill.

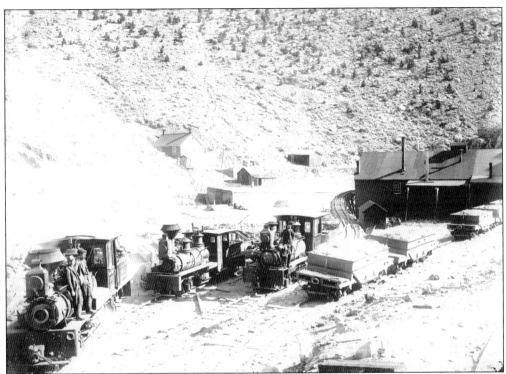

This 1890s view shows the Gilpin Tramway's engine house in Black Hawk. In the foreground from left to right are Engine Nos. 3, 1, and 2. The long building to the left and rear of the engine house is the Gilpin's "warming house." During the winter months, this heated building was used to thaw frozen ore shipments. Loaded ore cars would be placed in the warming house overnight and would usually be ready for shipment the next day. (A.M. Thomas photo.)

THE GILPIN RAILROAD COMPANY

MEMO FOR USE OF AGENT AND GENERAL FOREMAN

Black Hawk Station Aug 24

mor G.R.R. Co.

From Black Hawk

nee woods m. Co.

To woods mine

ARTICLES	WEIGHT	RATE	FRE
Car water.		10	10

The Gilpin Tramway not only picked up and delivered ore, it also carried water. The water was often used by some of the more isolated mills and mines where water was scarce. This 1913 receipt is for a shipment of water delivered to the Woods Mine south of Nevadaville near the Topeka Mill. The delivery was probably made in Car No. 300, a converted coal car rebuilt specifically to carry water.

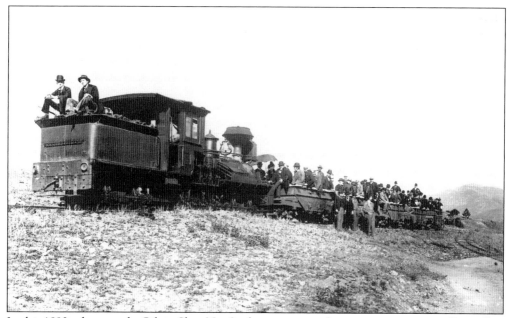

In this 1890s photograph, Gilpin Shay No. 3 takes a turn at a five-car excursion train. Regardless if they were on two-foot or three-foot rails, train excursions were extremely popular in the Clear Creek District. Representative of the gender ratios in the surrounding towns, the number of men on this trip greatly outnumbered the number of women. (Harry H. Buckwalter photo.)

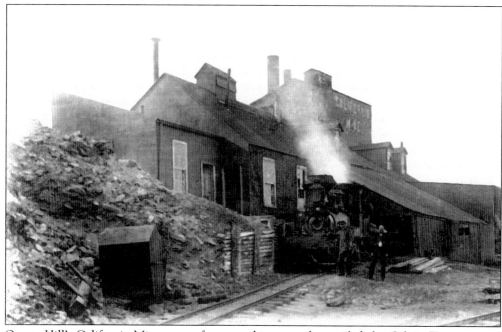

Quartz Hill's California Mine was a frequent shipper and provided the Gilpin Tramway and Black Hawk mills with plenty of ore. This photo shows Gilpin Shay No. 3, aptly named "Quartz Hill." (A.M. Thomas photo.)

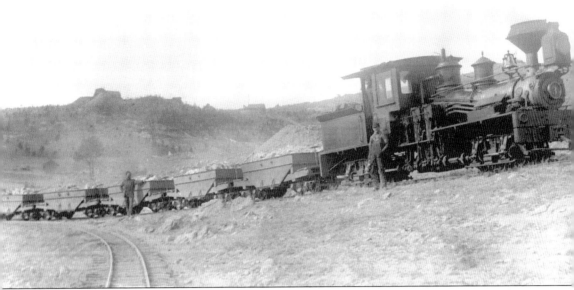

Russell Gulch is the scene of this photograph, taken of Engine No. 3 and her crew. This locomotive was built by the Lima Locomotive Works in 1889 and was one of five similar two-foot-gauge engines using the patented Shay gearing mechanism.

The diminutive nature of the Gilpin was an attraction for local tourists as is evidenced in this early 1900s tongue-in-cheek photograph. Ore Car No. 100 had a capacity of 20,000 pounds and was a little over 17 feet long.

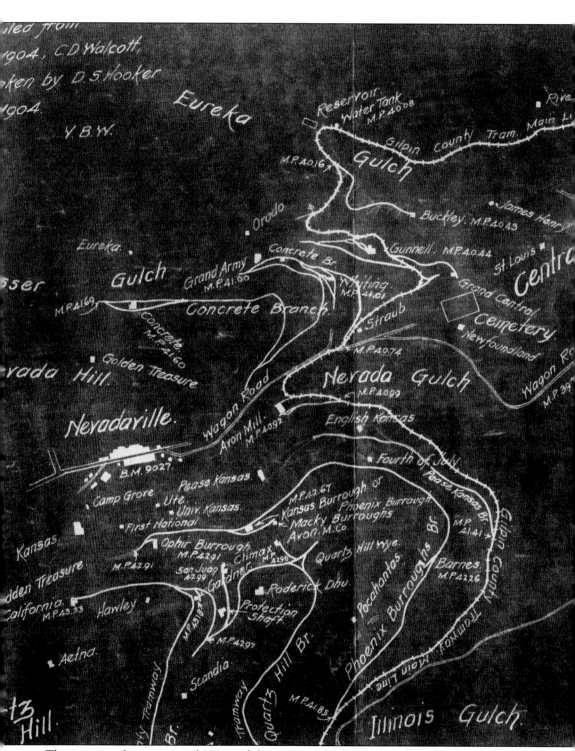

This rare map dates to around 1904 and shows most of the areas served by the Gilpin, including Nevadaville on the left, Central City in the middle, and Black Hawk on the extreme right. This map was probably part of the assimilation process for the Gilpin's acquisition by the Colorado

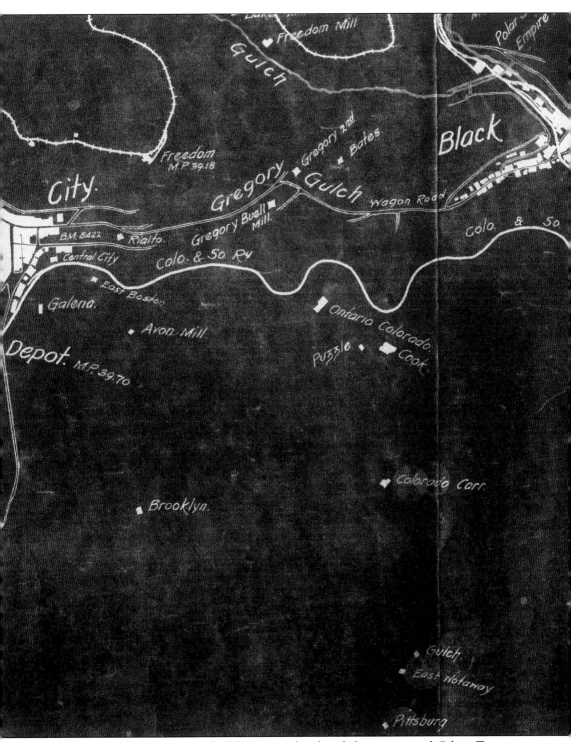

& Southern. By 1906 the merger had been completed and the reorganized Gilpin Tramway emerged as the Gilpin Railroad.

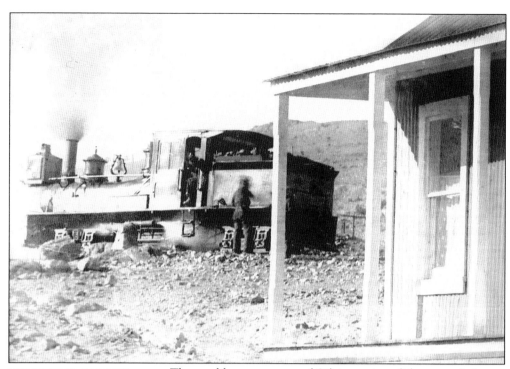

The toy-like appearance of Gilpin engines did not preclude them from being properly maintained. Until 1900 the Gilpin had only three Shay engines and each was moving almost 100 tons of ore a day. The steep grades were hard on the engines and maintenance scenes such as this one were common.

The fact that the Gilpin was designed to serve mines and not necessarily communities is shown on this daily report from 1904. Listed here are many of the mines around Nevadaville, west of Central City. Picking up 17 loaded cars probably required Engine No. 5 to make several trips.

In this early 1900s photo, a Gilpin engineer tends to the mechanical needs of Engine No. 4. This locomotive was built by Lima in 1900, had 24-inch wheels, and weighed 34,800 pounds. Connected to the engine is Ore Car No. 35. Originally built in 1887 as a half-cord gondola, No. 35's capacity was later increased three-quarters of a cord.

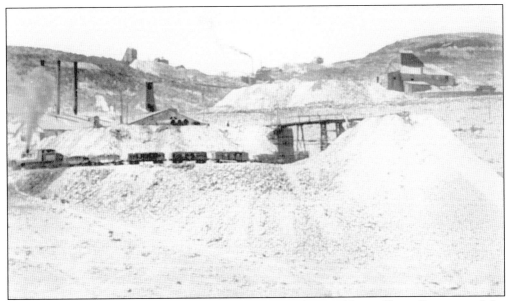

Although the engine number in this photograph is not discernable, its Shay silhouette and the tiny ore cars with "G T" initials on the side leave little doubt as to the operator. The light rail of the Gilpin and its narrow roadbed made it ideal for connecting to the scattered mines along the right-of-way.

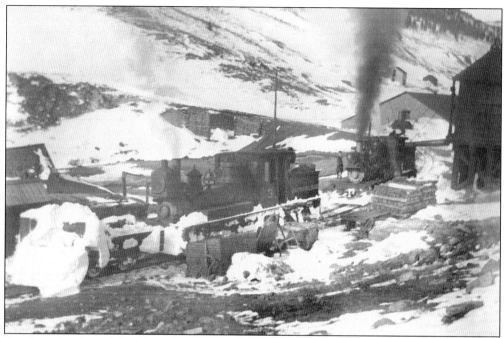

For the railroaders of the Clear Creek District, winter could last half of the year. Snow removal on the Gilpin was tough work as even small snow banks could derail the light locomotives. This photo shows the Gilpin's two newest engines, No. 4 and No. 5, bucking snow near Nevadaville.

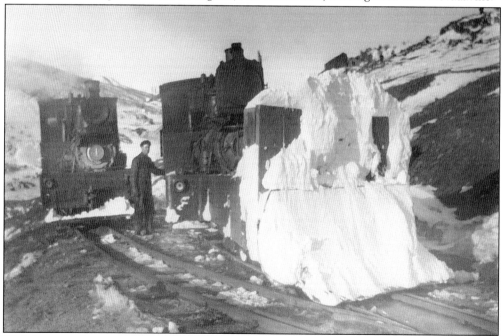

With homemade snowplow No.02 out in front, Engines No. 3 and No. 4 pause for water at the Eureka Tank during one of several blizzards that hit the Clear Creek District during the winter of 1912–1913. While the Colorado & Southern was able to bring up their steam-powered rotary, the men of the Gilpin depended on No. 02 and their own shovels.

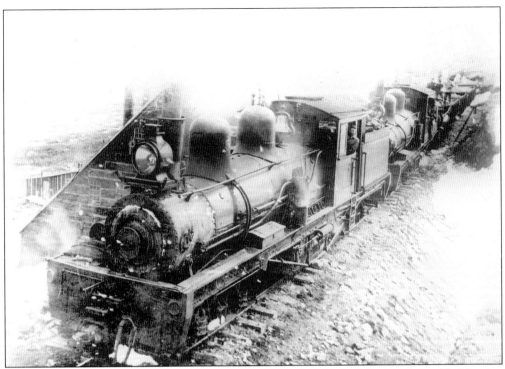

This rare photo shows a Gilpin double-header with Engine No. 5 in front and possibly No. 4 in back. At 36,200 pounds, the 1902 vintage locomotive No. 5 was the largest of the five Gilpin engines and, like her sisters, was built by the Lima Locomotive Works.

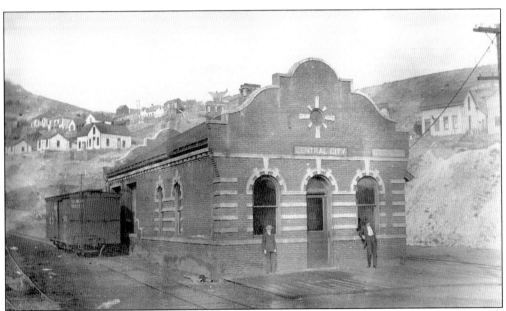

The Gilpin Tramway and the Colorado & Southern Railway shared the former UPD&G's brick offices in Central City. The sign to right of the "Central City" depot board reads "General Office The Gilpin Tramway CO."

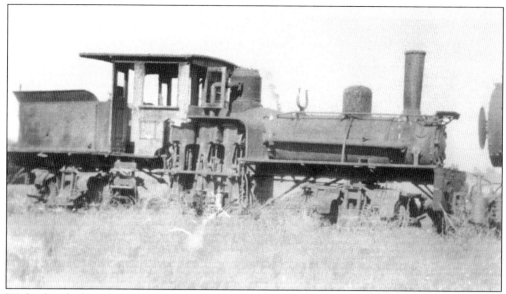

With the decline in mining around the time of World War I, the Gilpin Railroad was abandoned in 1917. Its engines became expendable and eventually sent to Denver, where Nos. 3–5 were converted to narrow gauge for re-sale. In this photo, Gilpin Engine No. 4 sits on a dead track at Morse Brothers. The two-foot gauge that served the Clear Creek District so well was too unique for the local mining market and the engines were scrapped in 1938. (Richard H. Kindig photo.)

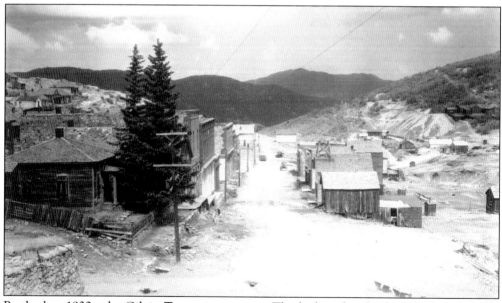

By the late 1930s, the Gilpin Tramway was gone. The little railroad, which had no formally established right-of-way but seemed to "go everywhere," had been scrapped for over two decades. The railroad was not the only victim of the mining slump. Local communities also declined. While the railroad was torn up and sold for scrap, as this image illustrates, it took a little longer for the town of Nevadaville to wither.

Six

COLORADO & SOUTHERN RAILWAY

The competent leadership of receiver Frank Trumbull gave new life to the struggling UPD&G, and in November 1898 bondholders purchased the road. The UPD&G and the DL&G were then reorganized as the Colorado & Southern Railway. The new management set about purchasing new equipment and worked hard at attracting new passenger and freight business. The C&S did some local expanding and purchased the Gilpin Tramway while also maintaining a special relationship with the Argentine Central. Tourism remained a good source of income and tunnels designed to drain flooded shafts helped some mines increase their output. The first decade of its existence were the halcyon years of the Colorado & Southern Railway, but tougher times lay ahead.

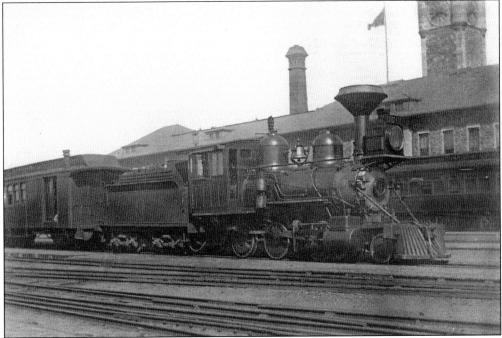

Many trips to and from the Clear Creek District began and ended here, at Denver's Union Station. In this photo, Engine No. 9 is dwarfed by nearby standard-gauge passenger cars and the massive walls and clock tower of the depot.

With the establishment of the Colorado & Southern Railway, the sign hanging outside this UPD&G ticket office would become a thing of the past. Located in Denver at the corner of Seventeenth and Curtis, this office served both the UPD&G and the Denver, Leadville & Gunnison. This photo was taken in the mid-1890s when the offices displayed advertising of both railroads.

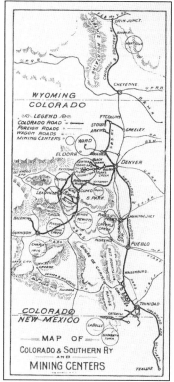

This Colorado & Southern map dating from 1899 illustrates the new C&S system, including the Clear Creek basin and the mining districts of Leadville, Kokomo, and others formerly served by the Denver, Leadville & Gunnison.

This 1899 advertising piece was how General Passenger Agent Thomas E. Fisher introduced the new Colorado & Southern Railway to shippers and the traveling public. The C&S advertising department marketed the railroad as "The Colorado Road," a slogan it used throughout the early part of its history.

"THE COLORADO ROAD"

Colorado and Southern Railway

This Company is essentially a Colorado institution, comprising the lines formerly operated as the U. P. D. & G. Ry., "The Gulf Road," and the D. L. & G. Ry., "The South Park Line." Its lines reach the best mineral districts of Colorado, the most popular health and pleasure resorts, the most magnificent scenery in picturesque Colorado and the most productive farming centers. Colorado is now more than ever attracting the attention of the outside world and her wonderful resources are being rapidly developed. As an attractive place of residence no other state holds out more flattering inducements.

"THE COLORADO ROAD"

Is anxious to disseminate information about the wonders of Colorado and will gladly send any one interested in the subjects carefully and conscientiously prepared publications on the mineral resources, the agricultural products, the scenic and resort attractions, and on that greatest of resources, Colorado's matchless climate.

Kindly advise us in what you are particularly interested, addressing

T. E. FISHER
GENERAL PASSENGER AGENT
DENVER, COLO.

The Colorado & Southern was fortunate to have the energetic Thomas E. Fisher as their general passenger agent. Fisher saw real potential in the C&S narrow gauge and expended a lot of energy in promoting the Georgetown Loop and the surrounding area.

69

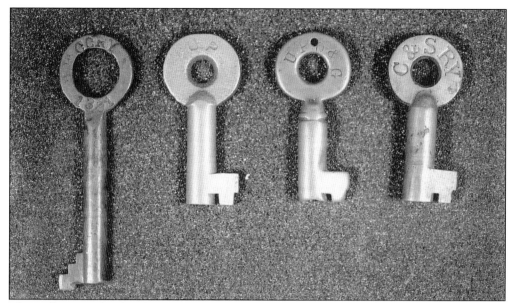

This collection of railroad keys traces the lineage of the C&S Railroad from when trains first entered the Clear Creek District. Shown from left to right are a coach key from the Colorado Central, a Union Pacific switch key, a Union Pacific, Denver & Gulf switch key, and a Colorado & Southern switch key. (Doug Summer and Allan C. Lewis collections.)

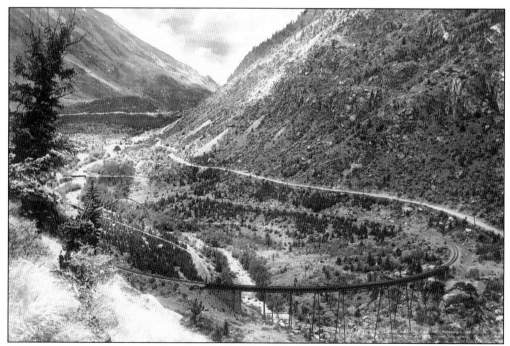

Few views captured the beauty and the engineering achievement of the Georgetown Loop like this L.C. McClure image. The photograph shows the massive 18-degree turn of which the "High Bridge" was a part.

The Clear Creek Valley forms the backdrop for these two women posing on the rear platform of a Colorado & Southern coach, c. 1908. The warm dress of the women and the lack of an open observation car indicate that this was probably not taken during the tourist season.

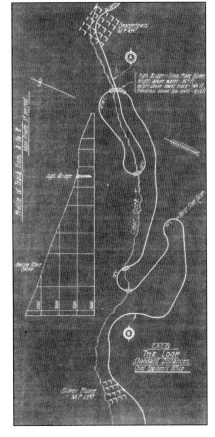

In the years soon following the incorporation of the Colorado & Southern, the railroad began to document much of its right-of-way. This layout of the Georgetown Loop was drawn in 1902 and illustrates all of the twists and turns between Georgetown and Silver Plume.

DENVER TO SILVER PLUME LOOP TRIP							
Dist. from Denver	STATIONS	No. 51. Mail and Express Daily	No. 53 Mail and Express Daily				
0	Lv.DENVER	8 10AM	3 20"				
2	" Argo	8 17"	3 27"				
8	" Arvada	f 8 30"	f 3 37"				
11	" Mt. Olivet	f 8 40"	f 3 45"				
13	" Wanamaker's Rh	f...	f...				
16	" Golden	8 52"	4 02"				
19	" Chimney Gulch	f 9 06"	f 4 13"				
22	" Guy Gulch	f 9 20"	f 4 32"				
24	" Elk Creek	f 9 36"	f 4 44"				
27	" Roscoe	f 9 48"	f 4 56"				
28	" Big Hill	f 9 52"	f 5 00"				
29	Ar.Forks Creek			9 55"			5 03"
29	Lv.Forks Creek			10 05"			5 12"
32	" Floyd Hill	f 10 17"	f 5 22"				
37	" Idaho Springs	10 37"	5 41"				
39	" Fall River	f 10 46"	f 5 49"				
42	" Dumont	f 10 55"	f 5 58"				
44	" Lawson	f 11 02"	f 6 06"				
46	" Empire	f 11 06"	f 6 11"				
50	" Georgetown (THE LOOP)	11 25"	6 26"				
54	Ar.SILVER PLUME	11 50AM	6 50PM				

SILVER PLUME TO DENVER LOOP TRIP					
Distance from Silver Plume	STATIONS	No. 52. Mail and Express Daily	No. 54. Mail and Express Daily		
0	Lv.SILVER PLUME (THE LOOP)	6 25AM	2 20PM		
4	" Georgetown	6 45"	2 42"		
8	" Empire	f 6 57"	f 2 56"		
10	" Lawson	f 7 02"	f 3 01"		
12	" Dumont	f 7 07"	f 3 08"		
15	" Fall River	f 7 14"	f 3 18"		
17	" Idaho Springs	7 24"	3 27"		
22	" Floyd Hill	f 7 40"	f 3 43"		
25	Ar.Forks Creek	7 50"			3 55"
25	Lv.Forks Creek	7 55"	4 04"		
26	" Big Hill	7 58"	f 4 08"		
27	" Roscoe	f 8 02"	f 4 12"		
30	" Elk Creek	f 8 12"	f 4 22"		
32	" Guy Gulch	8 22"	f 4 32"		
35	" Chimney Gulch	8 35"	f 4 44"		
39	" Golden	8 52"	4 56"		
41	" Wanamaker's Rh	f...	f...		
43	" Mt. Olivet	f 9 06"	f 5 06"		
47	" Arvada	9 20"	5 15"		
52	" Argo	9 33"	5 28"		
54	Ar.DENVER	9 40AM	5 35PM		

DENVER TO BLACK HAWK AND CENTRAL CITY								
Elevation	Distance from Denver	STATIONS	No. 151. Mail and Express Daily	No. 153. Mail and Express Daily				
5,170	0	Lv.DENVER	8 10AM	3 20PM				
5,655	16	" Golden	8 52"	4 02"				
6,880	29	Ar.Forks Creek			9 55"			5 03"
6,880	29	Lv.Forks Creek			10 00"			5 05"
7,177	31	" Cottonwood	f 10 08"	f 5 13"				
7,607	34	" Smith Hill	f 10 19"	f 5 24"				
8,032	36	" Black Hawk (THE SWITCHBACK)	10 30"	5 35"				
8,503	40	Ar.CENTRAL CITY	10 55AM	6 00PM				

CENTRAL CITY AND BLACK HAWK TO DENVER				
Population	Distance from Central City	STATIONS	No. 152. Mail and Express Daily	No. 154. Mail and Express Daily
3,114	0	Lv.CENTRAL CITY (THE SWITCHBACK)	6 55AM	3 10PM
1,500	4	" Black Hawk	7 20"	3 32"
........	6	" Smith Hill	7 30"	3 42"
........	9	" Cottonwood	f 7 39"	f 3 51"
12	11	Ar.Forks Creek	7 49"	4 01"
12	11	Lv.Forks Creek	7 55"	4 04"
....	25	" Golden	8 52"	4 56"
133,859	40	Ar.DENVER	9 40AM	5 35PM

This 1906 Colorado & Southern timetable references both the line to Black Hawk and The Loop. This timetable was published for April and only shows four trains daily to Silver Plume. The number of trains increased with the approach of the summer months.

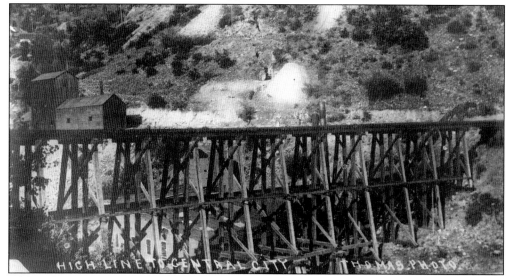

Although not as dramatic a route as The Loop, the tracks between Central City and Black Hawk gained sufficient elevation to afforded passengers a scenic look at local mining operations. Known as the "High Line," this 1901 photo shows an early view of C&S Engine No. 12 with two coaches and a baggage car. (A.M. Thomas photo.)

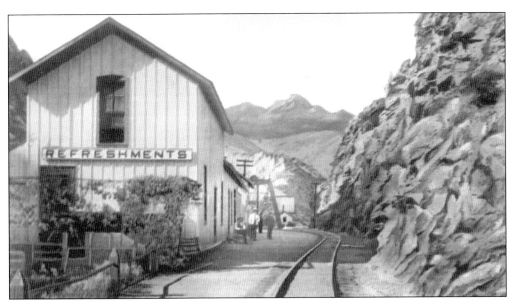

Depending on their destination, C&S passenger trains usually stopped at Fork's Creek for five to ten minutes. The brief interlude gave passengers the opportunity to walk around and stretch their legs or get a bite to eat at the eating house.

You will want **Luncheon** *of* course

The Colorado & Southern

Has at Silver Plume a very artistic and well-appointed Pavilion, where an excellent meal may be had, or just a light lunch, as you prefer. There is ample time for a full meal between trains. 🍃 🍃 🍃 🍃

At Forks Creek

About half way between Denver and the Loop, there is a lunch counter where refreshments may also be had.

This advertising piece shows how the C&S used the brief train layovers at various locations to their advantage. The handbill references the eating houses at Silver Plume and Forks, where lunch counters were always ready to accommodate hungry passengers.

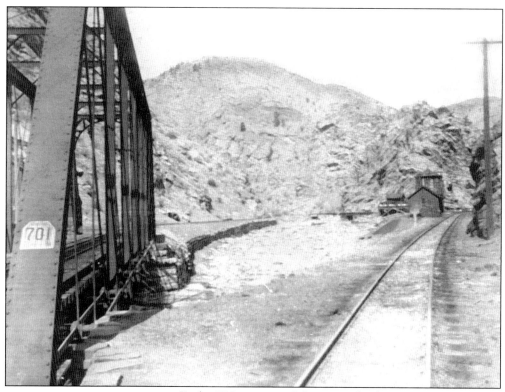

Bridge 701 was part of the network of C&S trackage at Fork's Creek. As a separation and consolidation point for inbound and outbound passenger trains, the area saw a great deal of traffic. The section house and water tank can be seen in the background.

Clad in an attention-getting red cover with a blue and white logo, the Colorado & Southern made their timetables readily available to the general public. This timetable from 1910 covered the entire C&S system but also had specific schedules for the trains to Silver Plume and Black Hawk.

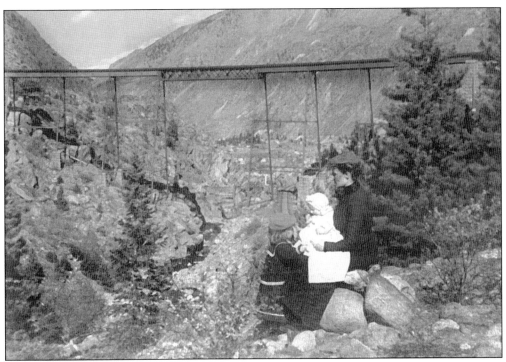

In the early 1900s, photographers and the Colorado & Southern Railway Passenger Department sometimes used wives and children in their advertising in the hopes of attracting additional business. The idea of increasing passenger revenues by promoting the "traveling family" concept worked well for the C&S in its first decade of operation. (B.L. Tingley photo.)

THE LOOP
BY MOONLIGHT

SAW A BRIDGE.
T LOOKED LIKE THIS.
IY JAW BEGAN TO DROOP
TOOK ANOTHER – THEN
SAW – THE GEORGETOWN
LOOP – THE – LOOP

By 1907 postcards had become a popular way of sending greetings and saving memories from trips and vacations. Many postcards were made of various Clear Creek locations, including this cartoon of the Georgetown Loop.

The stations along the Colorado & Southern came in a variety of construction mediums. The depots at Black Hawk and Georgetown were brick while this rustic depot at the Burleigh Tunnel near Silver Plume was built of wood and even sported a clock tower.

A trip over the Georgetown Loop was often the highlight of any Colorado vacation and it was not unusual for the event to be marked with a photograph. Some photographers had arrangements with the railroad where passengers could pose for the camera on their inbound trip and the photograph would be developed and ready upon their return.

The interest in amateur photography during the early part of the 20th century created a wonderful record for the modern railroad historian. The natural beauty of Clear Creek attracted many novice shutterbugs, including Denver-based salesman Frank Hunt. On a warm summer day in June 1908, Hunt, toting his new Kodak and a fishing pole, got off a C&S train near Floyd Hill and took this photograph. (Frank Hunt photo, Jim Oates collection.)

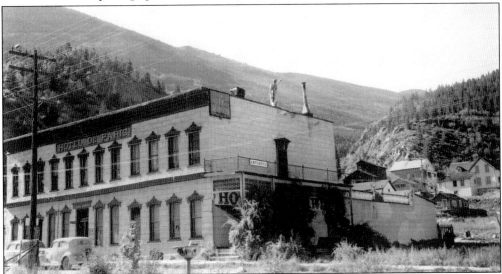

C&S passengers who wished to experience the Clear Creek District at a more leisurely pace had their choice of many local hotels. The finely appointed Hotel de Paris was known for its excellent service and lavish furnishings. Even in the 1940s, when this photo was taken, the name of the hotel's founder, Louis Dupuy, could still be seen over the entrance.

Form D. C. 14 8-10-6M

COLORADO & SOUTHERN RAILWAY CO.
DINING CAR AND HOTEL DEPARTMENT

DAILY CASH STATEMENT

Silver Plume Hotel, _2-29_ _____191_

Balance Forward	63	1 J	Cash remitted to Treasurer, Train No. _____ Date _____			
Meals and Lunch Counter Receipts	8	J J	Coupons remitted to General Auditor			
Room Receipts		70	Orders on Paymaster sent to Superintendent or			
Cigars and Tobacco Receipts		90	Master Mechanic _(Give Name)_			
Laundry Receipts						
Coupon Book Nos.	10	1 2				
Baths, 25c.						
			Balance on Hand		73	30
Total	73	30	Total			

O. B. Dutton Manager.

The Colorado & Southern Dining Car and Hotel Department consisted of several different lunchrooms, one of which was located in Silver Plume. This daily cash statement from 1913 shows the money taken in for meals and cigars.

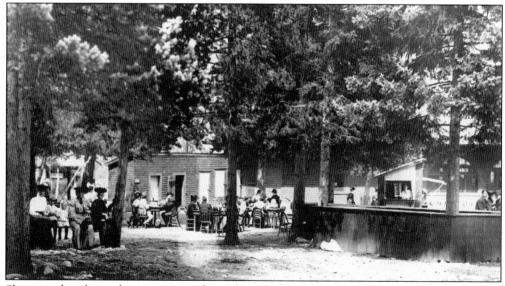

Shown in this photo, the picnic grounds at Silver Plume were very popular with C&S passengers. Located near the tracks of both the C&S and the Argentine Central, tourists had the option of either bringing a lunch basket with them or purchasing a meal at the Silver Plume lunchroom. (Louis C. McClure photo.)

Seven

ARGENTINE CENTRAL RAILWAY

The popularity of the Colorado & Southern's Loop Trip gave rise to the Argentine Central Railway, the last major railroad construction project in the Clear Creek District. In 1905 Edward Wilcox proposed to build a railroad from Silver Plume along a steep projection up Pendleton Mountain and then take a southwesterly course toward several Wilcox owned properties, including the Waldorf Mining and Milling Company. This idea became the Argentine Central, a three-foot narrow-gauge railroad which, like the Gilpin, used switchbacks and geared locomotives to tackle the steep grades of its right-of-way. Along this route were several mines and the "town" of Waldorf, which in 1907 reportedly had the highest post office in the world. The railroad derived much of its income from tourists as C&S passengers often elected to extend their trip and take the Argentine Central to the summit of Mount McClellan. The railroad experienced marginal success through 1908 but despite the wonderful view it provided, the Argentine Central could not sustain itself on passenger receipts. After operating sporadically for several years, the Argentine Central was reorganized, first becoming the Georgetown & Grays Peak in 1913 and soon after the Argentine & Grays Peak. The railroad lasted until 1918, was abandoned in 1919, and scrapped several years later.

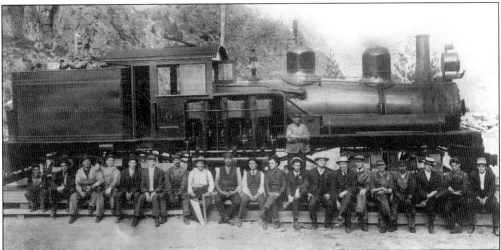

It appears that the Argentine Central emptied their Silver Plume shops to take this c. 1908 photo. Shown in the image are a number of railroad employees, including locomotive and train crews, carpenters, and office and shop personnel.

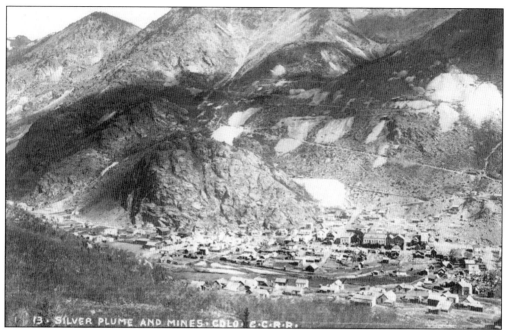

The town of Silver Plume was the junction point between the Colorado & Southern and the Argentine Central. The reference to the Colorado Central on the bottom of the image indicates that this photo was probably taken prior to the construction of the Argentine Central. The right-of-way used by the AC was similar to the wagon road switchbacks shown in this photo. (William H. Jackson photo.)

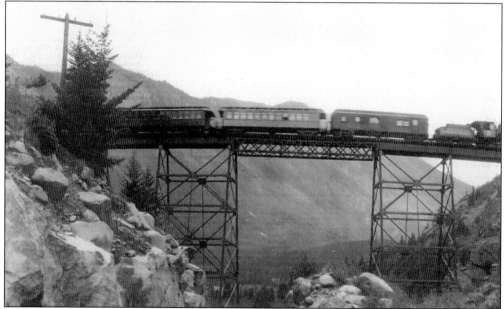

The relationship between the C&S and the Argentine Central went beyond their Silver Plume connection. Both roads used C&S equipment, some of which was leased by the Argentine Central. There was also a strong dependency on the passenger revenue brought in by C&S trains like this one shown on the "High Bridge" headed by Engine No. 5.

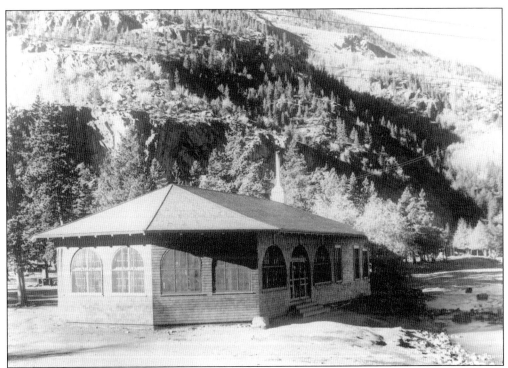

Some of the passengers who got off the C&S train in Silver Plume quickly boarded the Argentine Central to continue their sightseeing tour. One of the major congregating points for the joint venture was the Colorado & Southern's Silver Plume lunchroom, built in 1899. This photo of the eating pavilion was taken around 1905. (Louis C. McClure photo.)

The wonderful scenery of Clear Creek made getting to places like Georgetown and Silver Plume half the fun. The Loop Trip and the Argentine Central were popular with young couples like these passengers. Three Colorado & Southern open observation cars can be seen waiting in the background.

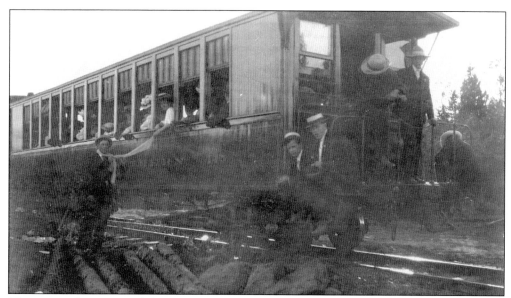

The camera has captured the attention of these Mount McClellan-bound passengers shown waiting on and around one of the excursion coaches. The excursion car is C&S No. 145, one of several cars leased by the Argentine Central.

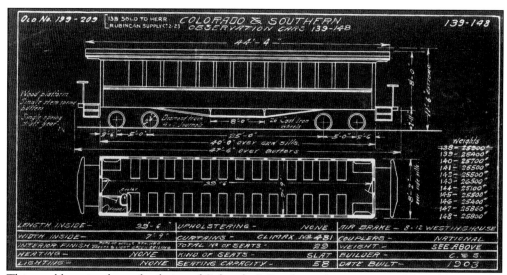

This rare blueprint shows the design of Colorado & Southern observation cars Nos. 139–148. The cars were nearly 48 feet long and could carry 58 passengers. These cars were used on both the C&S and the Argentine Central. While the blueprint states that these were built in the C&S shops, others, possibly an earlier series, were reportedly built by Denver's Woeber Carriage Company.

Edward Wilcox first came to the Clear Creek District in the early 1880s. He was a miner, an engineer, a Methodist minister, and eventually became the president of the Argentine Central. Wilcox's intent was to build a railroad south from Silver Plume toward several claims in the Argentine District, including his own.

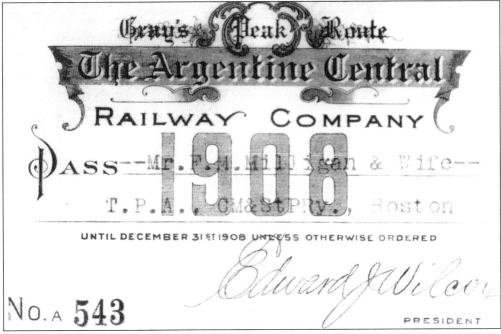

Like the Georgetown Loop, it did not take long for the trip up Mount McClellan to become popular with Colorado visitors. This was especially true of tourists who, through their association with other railroads, could obtain a free pass. This 1908 Argentine Central pass was issued to the traveling passenger agent working out of the Boston office of the Chicago, Milwaukee, St. Paul & Pacific Railroad.

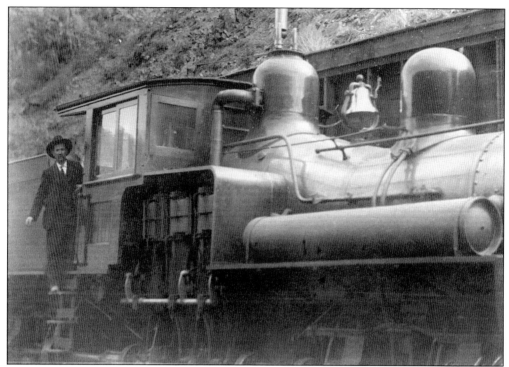

Georgetown photographer George Dalgleish took this photo of the Argentine Central No. 1, the railroad's first locomotive. The engine was built by the Lima Locomotive Works and delivered at the end of August 1905. (George Dalgleish photo.)

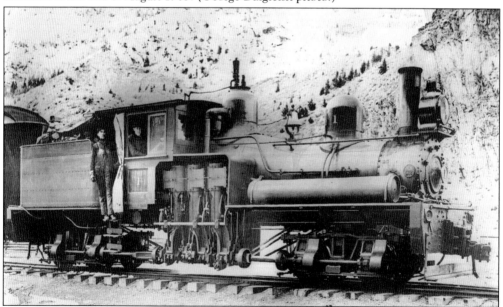

Engine No. 1 stands tall in this 1905 photograph with engineer William Dunning (seated) and fireman George Ames. Both men were seasoned railroad veterans and quickly gained responsible positions within the organization. Dunning became a master mechanic while Ames was elevated to trainmaster.

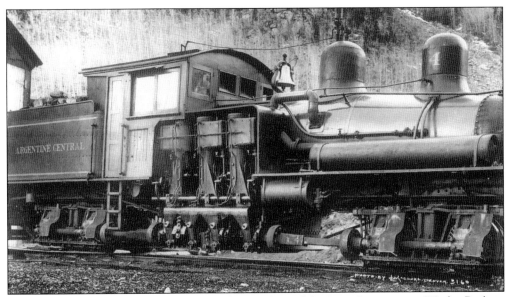

Argentine Central Engine No. 4 was another product of the Lima Locomotive Works. Built in 1907, it was very similar to its sister locomotive, Engine No. 5. This photo shows No. 4 in front of the Silver Plume engine house. (Louis C. McClure photo.)

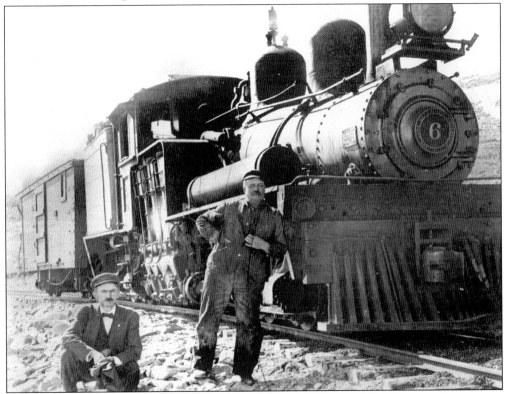

In this rare photo, the proud crew of Argentine Central No. 6 stands next to their locomotive. The man standing to the left of the pilot is believed to be engineer A.G. "Bert" Pope. On the rear of this train is a rare glimpse of an the Argentine Central caboose.

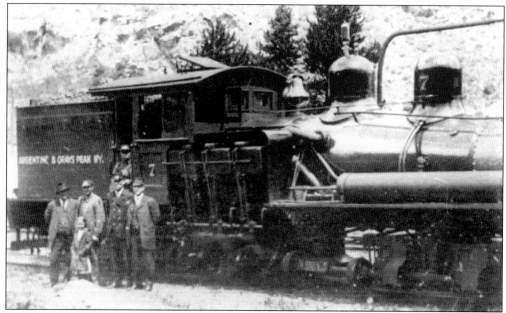

Less than 10 years into its history, the Argentine Central changed hands and became the Georgetown & Grays Peak. In 1913, Engine No. 7 bore the name of the Argentine & Grays Peak, the operating company formed by the G&GP. Built in 1909, No. 7 was the last and the largest of the railroad's Shay locomotives.

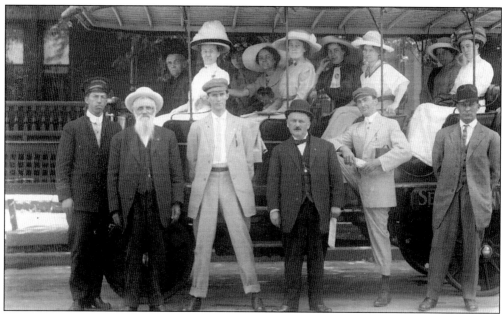

Not all trips to the top of Mount McClellan began in Silver Plume. These members of a Denver Omnibus and Cab Company tour prepare to depart for Denver's Union Station. Here they will take the C&S to Silver Plume for a round trip on the Argentine Central. Some tour packages provided an "official" guide and photographer who took images of passengers along the way and would then sell the developed snapshots at the conclusion of the trip.

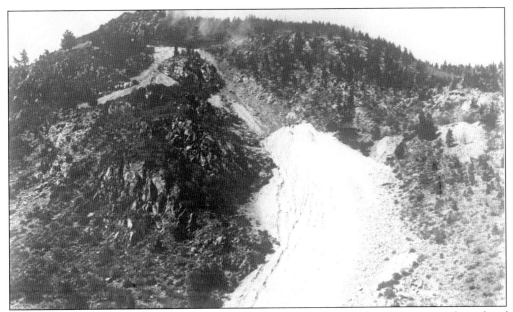

Upon leaving Silver Plume, the tracks of the Argentine Central headed east up the side of Leavenworth Mountain, reaching two switchbacks and then Devil's Slide, the subject of this photo. High above the tailing pile, wisps of smoke betray an Argentine Central train on its way to Mount McClellan.

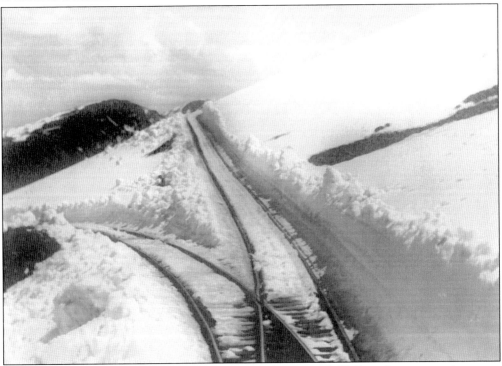

To gain the elevation needed to reach Waldorf and Mount McClellan, the construction crews of the Argentine Central incorporated a number of switchbacks into the line. This 1908 photo shows the effort required in keeping these switchbacks clear of snow.

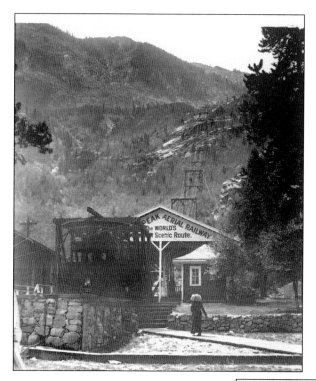

Silver Plume's other scenic attraction was the Sunrise Peak Aerial Tramway. Built in 1906, the tramway was also intended to take advantage of the layovers with Silver Plume trains. Although some Colorado trams had been built specifically to haul ore from isolated mine sites, the Sunrise Peak tram was designed to carry people, like the lady in this photo walking toward the lower terminal.

This photo of the Sunrise Peak Aerial Tramway's powerhouse and terminal also shows the proximity of the tramway's lower station to the tracks of the Colorado & Southern Railway. In the foreground is a C&S bridge and switch stand. By billing itself as "The World's Greatest Scenic Route" the tramway had quite a reputation to live up to.

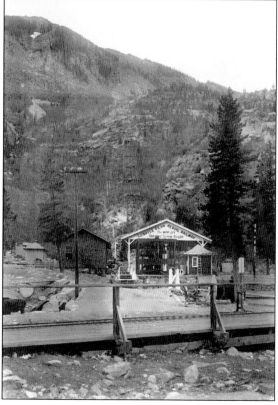

This joint brochure features both the Colorado & Southern Railway and the Sunrise Peak Aerial Tramway. One of the tram's several dozen towers and a summit-bound gondola full of tourists are shown on the cover. In 1907 a roundtrip ride on the tram cost $1.

On line of

Colorado & Southern Railway

Three hours from Denver

Sunrise Peak Aerial Railway--
World's Greatest Scenic Route

The end of the line for the Argentine Central is shown in this 1907 photograph at the top summit of Mount McClellan. High above the tree line passengers shared an unobstructed view of the surrounding mountains. The facilities in this photo consisted of the outhouse to the left and below Engine No. 4 as well as the structures around the Ice Palace.

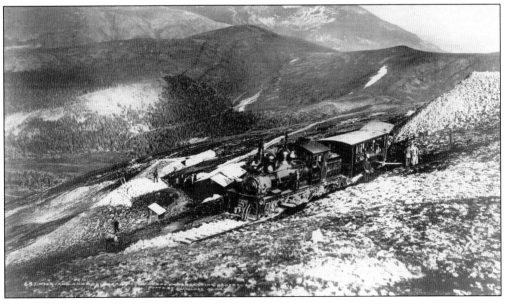

Compliments of

The East Argentine C. M. M. P. & C. Co.

HOME OFFICE, GEORGETOWN, COLORADO.

Properties in East Argentine Mining District, five miles from Georgetown, by good wagon road.

GOLD BELT MAP OF COLORADO

Showing the Great Gold Belt of the Rocky Mountains.

FROM U. S. GOVERNMENT SURVEYS

This map was part of an early prospectus commissioned by the East Argentine Mining and Tunnel Company and shows the "belt" of gold ore that was claimed to exist in a diagonal line across the state of Colorado. The East Argentine District was located between Silver Plume and Montezuma near the southern terminus of the Argentine Central.

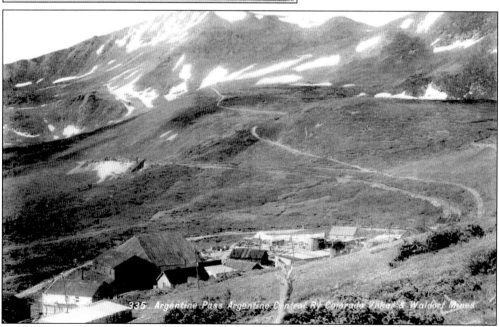

The reign of the Argentine Central occurred at a time when postcards were very popular with Colorado travelers. A number of postcards were sold of scenes along the right-of-way including this one of Waldorf.

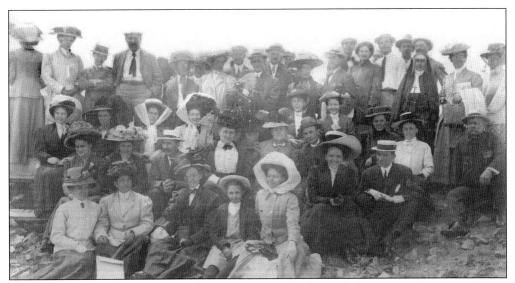

This hearty group of tourists, including a nun, paused to have their picture taken near the summit of Mount McClellan on July 27, 1908. In the early years of the Argentine Central's operation, Silver Plume and Georgetown photographers made money taking images of tourists and travelers.

Once the passengers of Argentine Central trains approached Waldorf, the surrounding mountains provided a fantastic view. This photo shows "Grey" (Gray's) and "Torry" (Torry's) Peaks, two of the more prominent features of the Mount McClellan trip.

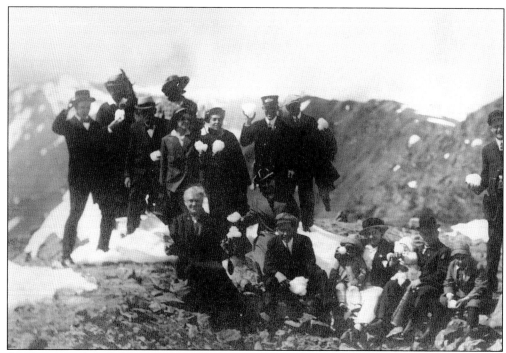

Summer snowball fights on Mount McClellan were a favorite pastime for summit-bound passengers. In this photograph, probably taken during the operation of the Argentine & Grays Peak Railway, even the conductor joins the fun.

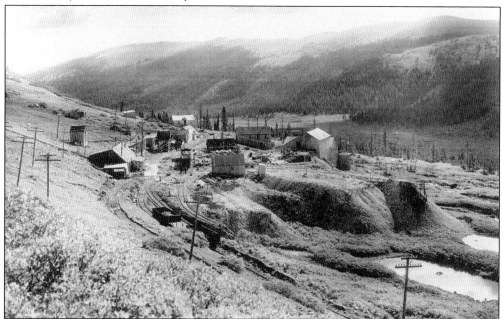

The tracks of the Argentine Central formed "Main Street" in this 1906 image of the town of Waldorf. The Waldorf Mining Milling Company workings are on the right, and to the left of the tracks, several outbuildings followed by the Argentine Central's water tank and post office can be seen. In the distance along the tracks are the eating house and depot, still under construction.

Eight

WRECKS AND EFFECTS

Operating a mountain railroad was tough work. Roadbeds projected along creeks and river banks to facilitate a more gradual access to higher elevations made the tracks prone to flooding during spring thaws and storms. The higher altitudes reached by mountain railroads usually required greater snow removal capabilities. Other hazards hindered rail operations as well, including accidents, worn and obsolete equipment, fire, signal and telegraph miscommunications, organized labor, and robberies—calamities that had the potential to befall any railroad. In this aspect, the Colorado & Southern Railway was no different than other mountain railroads as floods, blizzards, and wrecks were no strangers to Clear Creek railroading.

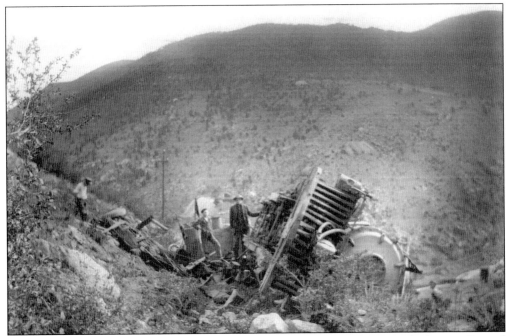

With her number plate obscured by weeds, C&S Engine No. 21 lies in a ditch near Central City. The wreck occurred on August 30, 1912 near one of the High Line switchbacks. This engine was originally built by Brooks in 1882 as DSP&P No. 29 and later DL&G No. 156. It was scrapped in 1923.

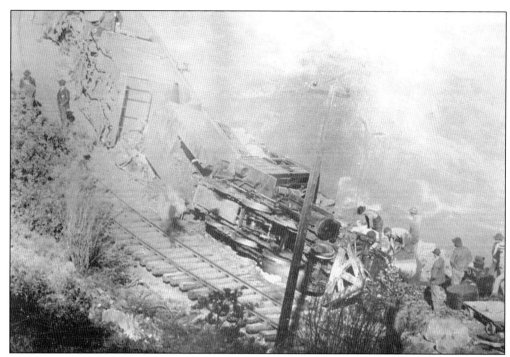

The Union Pacific Denver & Gulf had its share of catastrophes too. In this 1895 photo, Engine No. 108 and an unidentified baggage mail car have come off the tracks and lie on their side along Clear Creek. In the aftermath, several men retrieve mail from the postal section of the head-end car.

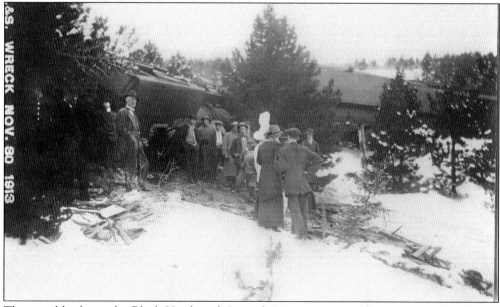

The switchbacks in the Black Hawk and Central City areas were often a source of problems for the C&S, and November 30, 1913 was no exception. On that day Engine No. 69 left the tracks taking a baggage car with it. A bruised and battered fireman was thrown clear during the derailment but the engineer was not as fortunate and died in the wreckage.

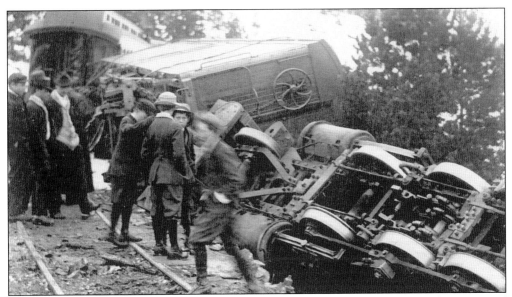

Another view of the November 30 wreck shows the overturned drivers and undercarriage of Engine No. 69. Notice that the photographer has placed an "X" on the bottom right-hand driver of the engine. This marks the spot under which the body of engineer James Duffy was found. According to the photographer's notations the body was still trapped under the cab when this image was taken.

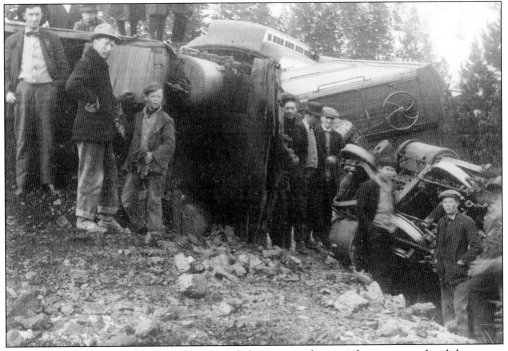

Although the photographer failed to record the correct date on the negative, he did manage to capture the crowd of curious passengers and onlookers that assembled at the wreckage. The C&S was fortunate that the coaches further to the rear of the train did not derail as many of the passengers could have been injured.

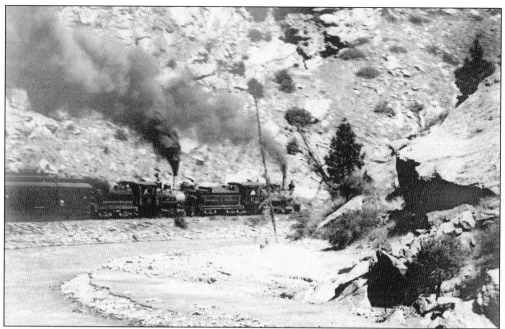

While the banks of Clear Creek had been widened to accommodate a railroad, they did little to keep the tracks in place during times of flood. This *c.* 1920 photo shows Engines No. 6 and No. 62 double-heading a passenger train, demonstrating just how susceptible the right-of-way was to flood damage.

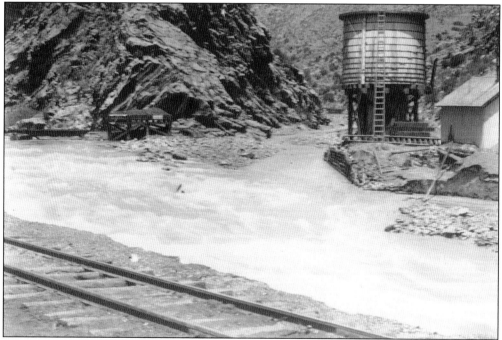

When Clear Creek flooded, it was capable of great carnage, which often came without warning. Although most of the Fork's Creek structures were left in place by this flood, the water did considerable damage to the tracks, ties, and roadbed.

Swollen creeks and rivers could wash out considerable lengths of railroad right-of-way. Such was the case on May 5, 1900 when a flood hit Clear Creek near Bridge No. 1038. The two men sitting on the far end of the washout are probably the vanguard of track crews dispatched to repair the damage.

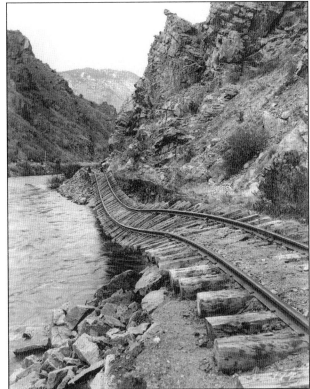

Storms along the C&S right-of-way of didn't always just wash away the ballast; sometimes they took the ties and rail too. In another photo of the May 5, 1900 flood, railroad employees look at what earlier had been the main line.

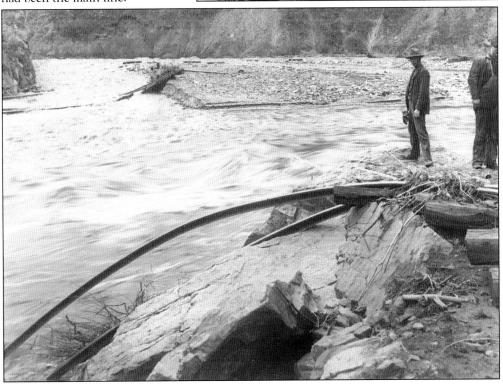

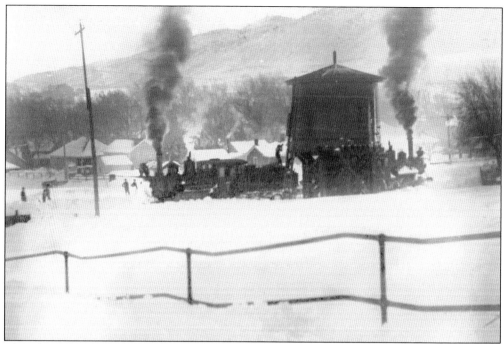

This photograph, probably taken during one of the severe snow storms of 1913, shows C&S No. 7 and No. 8 at the town of Golden's water tank. Golden was the last westbound water stop before trains entered the Clear Creek Canyon. It was also the end of the dual-gauge tracks.

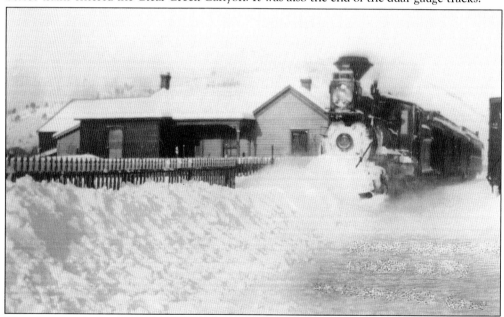

This photograph shows Colorado & Southern Engine No. 12 fighting its way into Idaho Springs during a blizzard. Although this blizzard of March 26, 1899 might have been one of the first experienced by the newly formed C&S, the railroad would face many more. Formerly known as UPD&G No. 107, No. 12 would go one to serve the C&S for two more decades before finally being scrapped in 1923.

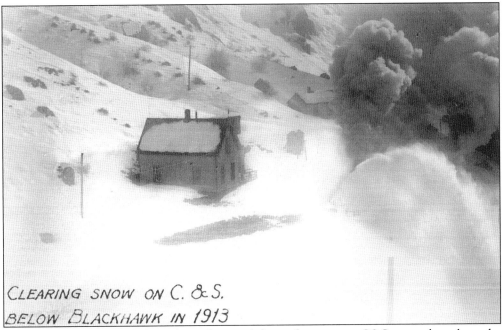

CLEARING SNOW ON C. & S.
BELOW BLACKHAWK IN 1913

Underneath billowing black smoke and tons of churned up snow, a C&S snow plow clears the tracks near Black Hawk. The winter of 1913 came with a vengeance and hit the Clear Creek District hard. In this photo taken on December 11, 1913, C&S Rotary No. 99200 makes a rare appearance on the High Line.

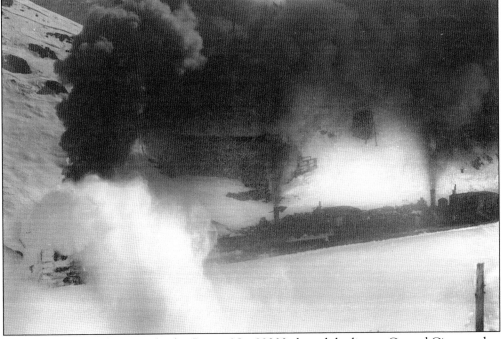

In January 1914, only a month after Rotary No. 99200 cleared the line to Central City, another heavy storm hit the Clear Creek area. This view shows C&S No. 6 and several unidentified engines pushing a rotary through heavy snow near Black Hawk.

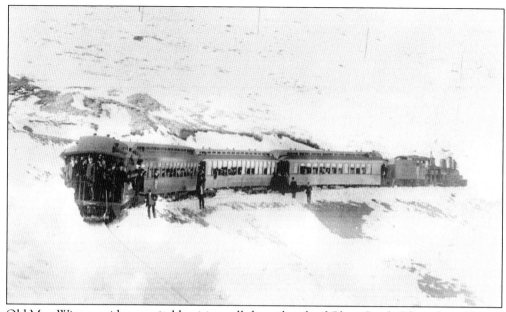

Old Man Winter paid an equitable visit to all the railroads of Clear Creek. Blizzards and heavy snows also plagued the Argentine Central, even in June 1909 when this photo was taken. In this view, the recently delivered Shay No. 7and four enclosed coaches push around a snow bank above Waldorf.

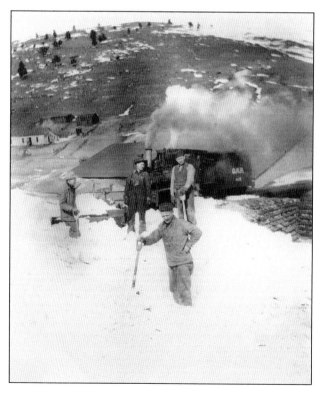

Unlike the Colorado & Southern, the Gilpin was not blessed with a rotary. However, it did have No. 02—a plow built by the C&S in 1906—and, as this image shows, employees with shovels. In another scene from the big storms of 1912–1913, crews pause in front of plow No. 02 while Gilpin Shay No. 4 and the seldom-photographed Caboose 400 bring up the rear.

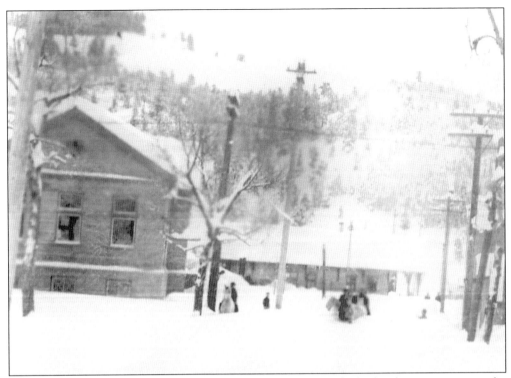

The storms of December 1913 were so great that even horses had a hard time navigating the streets of Idaho Springs. The Idaho Springs depot of the Colorado & Southern can be seen in the background. The head sticking out of a snow bank on the right side of the street gives testament to the depth of the snow.

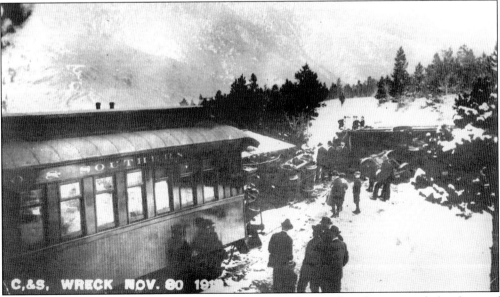

Another view of the fatal wreck of November 30, 1913 was taken from a rise behind one of the coaches. The overturned equipment in the background is the RPO car and the tender from Engine No. 69. The locomotive is farther down the hill behind the wreckage.

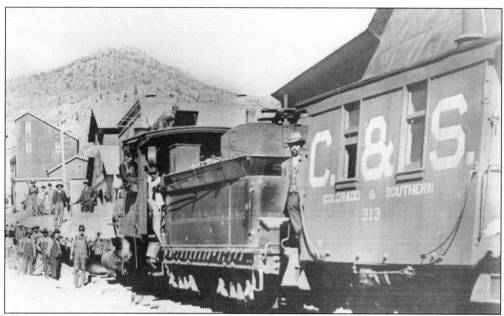

One 1910 downpour brought such a deluge upon Black Hawk that the streets filled with mud and rock. There was so much debris that the railroad was called upon to help clean it up. To gain better access to the area, the C&S built a spur down the street. This photo shows several rarities, including C&S Engine No. 66 and Caboose No. 313. (Joseph Collier photo.)

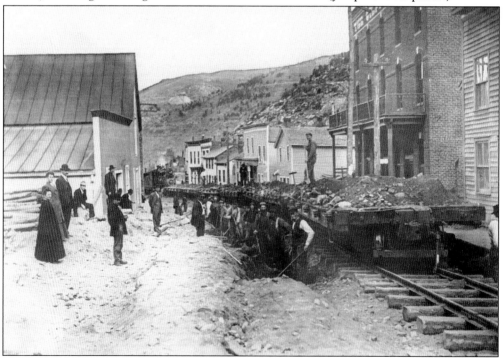

This view shows the opposite end of the work train above. Throughout the cleanup operation, the Gilpin Hotel (right) could now claim direct service via the Colorado & Southern Railway. In this photo, Engine No. 66 pushes six dirt laden flat cars. (Joseph Collier photo.)

Nine

ECONOMICS, EQUIPMENT, AND EVOLUTION

The general decline in mining that preceded World War I was also accompanied by a decrease in tourism. Many of the mines in the Clear Creek area had been in operation for some time and had reached the point where the investment required to sink additional shafts could not be recouped by the assay values of the remaining ore. Despite the advertising efforts of the C&S, these factors, along with the abandonment of the Argentine Central and a fall in popularity with the Georgetown Loop, saw a drop in both freight and passenger revenues. After the war, trucks, buses, and automobiles began to compete with the little narrow gauge. Hard times continued through the late 1920s when formal passenger service was discontinued on the Clear Creek line. While freight shipments stabilized a bit during the 1930s it was too little, too late. The final disposition of the three-foot empire came soon after when the tracks to Waterton were abandoned in 1942. This left only the narrow gauge around Climax, which was eventually converted to standard gauge in 1943.

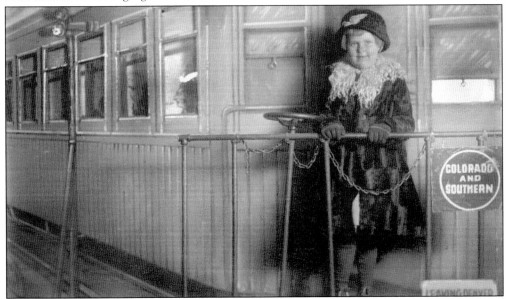

This photo, taken in 1919, shows a little girl standing in front of a photographers backdrop. Photographers often had an array of placards of the various railroads serving Denver and used the logo of the outbound railroad in their studios.

						FIRST CLASS					**TIME TA**
						Passenger					**STA**
						53 Daily	**51** Daily				
						P.M. 3.15	A.M. 8.10	KBY D CWYTO YB	……	.0	……DE

The figures shown above are for information only. The Denver Term…

						P.M.	A.M.				
						L 3.27	L 8.22	……	……	2.00	……CLEAR CI
						s	s	……	……	3.77	…..D. & S. L.
						s 3.41	s 8.36	……	89	7.02	……ARV
						f	f			9.02	……RI
						f 3.50	f 8.45	……	56	11.19	……MT. C
						f	f	……	0	13.25	……WIGG
						s 4.02	s 8.57	CWTO YDB	280	15.67	……GOL
						f 4.13	f 9.10	……	16	18.75	……CHIMNE
						f 4.29	f 9.22	……	18	21.57	……GUY C
						f	f			23.36	……BEAVER
						f 4.41	f 9.36	w	29	24.45	……ELK C
						f 4.53	f 9.47	……	11	26.76	……ROS
						4.57	f 9.51	……	18	27.89	……BIG
						s 5.00 s 5.10	s 9.55 s 10.05	CWY KB	17	28.71	……FORKS
						f 5.22	f 10.17	……	15	32.68	……FLOYI
						s 5.41	s 10.37	WO	830	37.69	……IDAHO S
						r 5.45	f 10.42	……	……	38.73	……STANLE
						5.47	10.44	……	64	39.91	……STANLE
						f 5.49	f 10.46	……	8	39.88	……FALL
						f 5.58	f 10.55	……	45	42.42	……DUM
						f 6.06	f 11.02	……	22	44.31	……LAW
						s 6.11	s 11.06	……	20	45.65	……EMI
						s 6.26	s 11.25	WYO	115	49.96	……GEORG
						A 6.50 P.M.	A 11.50 A.M.	YR KB	45	54.05	……SILVER
						Daily	Daily				(54.
						3.35 P.M.	3.45 A.M.				

This employee timetable from 1922 still showed four trains daily to Silver Plume and several more to Central City. However, encroachments from automobiles and buses would soon change this. Between 1923 and 1926, passenger revenues had dropped by nearly 50 percent. With

			FIRST CLASS	
			Passenger	
			52 Daily	54 Daily
			A.M. 9.50	P.M. 5.15

....... to govern all train movements between Denver and Clear Creek Jct.

			52	54
........	No Office	A 9.38	A 5.03
....		s	s
......	4.50 pm to 7.50 am	s 9.22	s 4.47
......	No Office	f	f
......	No Office	f 9.11	f 4.37
......	No Office	f	f
......	4.50 pm to 8.50 am	s 8.57	s 4.25
......	No Office	f 8.46	f 4.13
......	No Office	f 8.35	f 4.02
......	No Office	f	f
......	No Office	f 8.26	f 3.52
......	No Office	f 8.15	f 3.42
......	No Office	f 8.11	f 3.38
......	6.50 pm to 5.40 am	s 8.06 / 8.03	s 3.35 / 3.28
......	No Office	f 7.53	f 3.18
......	6.00 pm to 6.50 am	s 7.36	s 3.01
......	No Office	f 7.29	f 2.54
......	No Office		
......	No Office	f 7.26	f 2.51
......	No Office	f 7.18	f 2.43
......	No Office	f 7.12	f 2.37
......	No Office	s 7.07	s 2.32
......	6.00 pm to 5.40 am	s 6 52	s 2.17
......	7.50 pm to 6.70 am	L 6.35 A.M.	L 2.00 P.M.
			Daily	Daily
			2.18 17.18	3.18 17.18

ADDITIONAL SPURS

Clear Creek Subdivision

14.88	†..CONNORS (B. G.)...
30.06	†..CRUSHER (3 Rail)...
61.76	†..O'CONNEL'S (N.G.)..

operating expenses exceeding revenues the C&S discontinued passenger trains to Silver Plume and Central City.

The years before, during, and after World War I saw a vain effort by the C&S to attract passengers. This 1916 brochure was part of that effort and beckoned potential passengers to the wonders of Clear Creek and the fishing holes of the Platte Canyon.

The Colorado and Southern Railway Company

1927 B 6012

Pass——————Mrs. O.G. Perschbacher——————
Wife of Conductor.
Twenty Years Meritorious Service.

DURING CURRENT YEAR UNLESS OTHERWISE SPECIFIED
AND SUBJECT TO CONDITIONS ON BACK

VALID WHEN COUNTERSIGNED BY
BERT POUSMA, H.J. ALDERS, OR A.F. TINGLE

VICE PRESIDENT AND GENERAL MANAGER

Railroad passes were not only given out to railroad officials; they were also issued to employees of the home road. Considered one of the benefits of working for a railroad, passes often allowed for the free travel of employees and their families. This pass was issued for 1927, the last year of regular passenger service on the Clear Creek line.

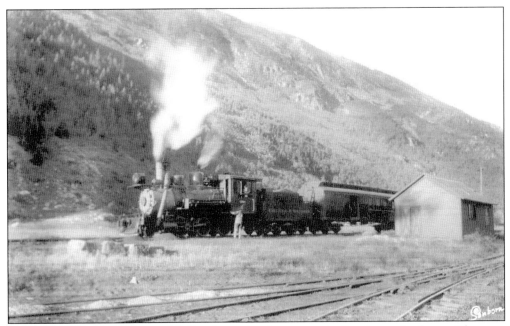

This photo shows C&S Engine No.7 making a brief stop near the Empire section house. The open door of the RPO car suggests that the train was picking up mail while one of the crew performs some brief maintenance. Scenes like this would only last a few more years. (Sanborn photo.)

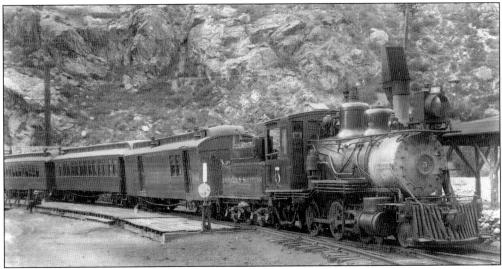

By 1926, when this photo was taken, passenger service on the Clear Creek line was coming to an end. It is interesting to note that despite its impending demise, this train still warranted two coaches and a baggage mail car.

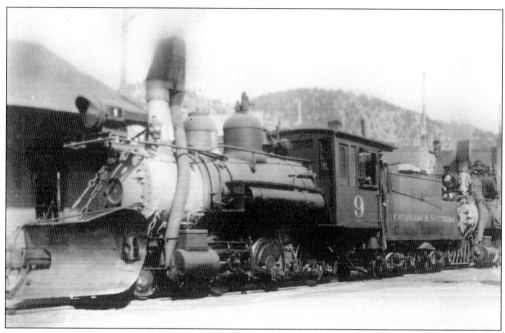

It was common in the earlier years of the C&S to use more powerful 2-8-0 Consolidations on the steeper grades of the South Park line while reserving the light Moguls for the runs up Clear Creek. In later years, however, both types of engines were sometimes used on Clear Creek runs. This photograph shows such an occasion with the combined power of Engine No. 9 and an unknown Consolidation.

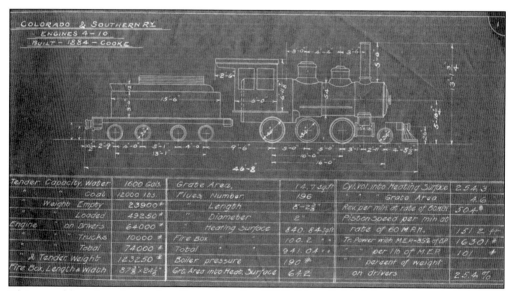

COLORADO & SOUTHERN RY.
ENGINES 4-10
BUILT - 1884 - COOKE

Tender Capacity Water	1600 Gals.	Grate Area	14.7 sq.ft	Cyl. Vol. into Heating Surface	254.3
Coal	12000 lbs.	Flues Number	196	Grate Area	4.6
Weight Empty	23900#	" Length	8'-2¾"	Rev. per min. at rate of 60 M.P.H.	504
Loaded	49250#	" Diameter	2"	Piston Speed per min at rate of 60 M.P.H.	151.2 ft
Engine on Drivers	64000#	Heating Surface	840.84 sq.ft	Tr. Power with M.E.P.-85% of BP	16301#
Trucks	10000#	Fire Box	100.2	per 1 lb of M.E.P.	101#
Total	74000#	Total	941.04	percent of weight	
& Tender Weight	123250#	Boiler pressure	190#	on drivers	25.4%
Fire Box, Length & Width	87⅜ x 24½	Grt. Area into Heat. Surface	64.2		

This rare blueprint shows the dimensions for C&S Class B-3A Moguls Nos. 4–10. These engines, built by the Cooke Locomotive Works in 1884, had exceptionally long service lives. Excluding No. 7, which was scrapped in 1929, the balance survived into the 1930s while No. 9 even outlived the railroad.

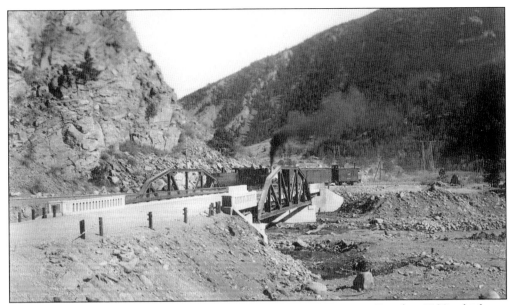

The Colorado & Southern Railway could not outrun progress. By the 1930s, highway construction had provided the residents of the Clear Creek Valley with good roads resulting in a marked increase in truck and automobile traffic. This photo foreshadows the changes to come, showing one of the new highway bridges across Clear Creek while Engine No. 70 works in the background.

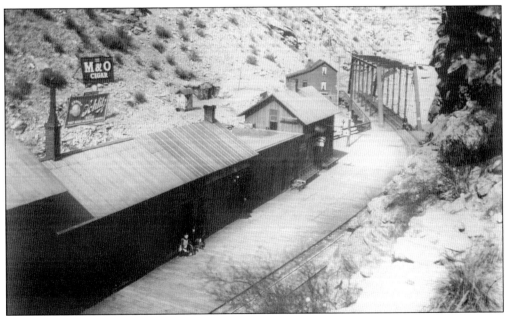

By the 1930s regular passenger service had been discontinued and freight traffic had dwindled. It was painfully evident to the C&S management that the railroad was headed for financial trouble. In a scene from happier times, several passengers wait at the Fork's Creek station while a velocipede pauses at the end of the bridge in the distance.

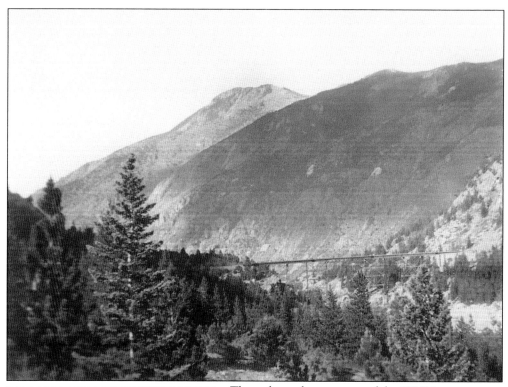

Throughout the presence of the C&S in Georgetown, the "High Bridge" and The Loop served as reminders of the golden days of railroading. However, by the late 1930s the trains loaded with tourists were gone and all that remained was an occasional freight. This photo shows the "High Bridge" around 1937.

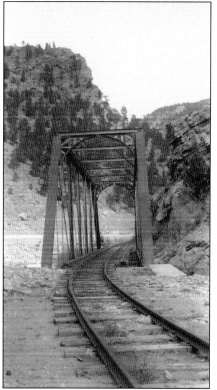

In the closing years of the C&S narrow gauge, some discretionary track work was set aside in an effort to preserve what operating income remained. Serving as a monument to deferred maintenance, this late-1920s photo shows weeds poking through an unballasted roadbed near one of the Clear Creek bridges.

The tracks and facilities west of Golden were not the only places where maintenance was lacking. This late 1930s view shows the C&S water tank near Argo at milepost 2. Years earlier this area had been home to a busy smelter which processed substantial amounts of Clear Creek ore.

Caboose No. 1003 brings up the tail end of this freight shown heading through Arvada in this 1939 photograph. The C&S facilities here included a passing siding, a connection with the Denver & Northwestern Railway, and the small depot shown here. (Ted Wurm photo.)

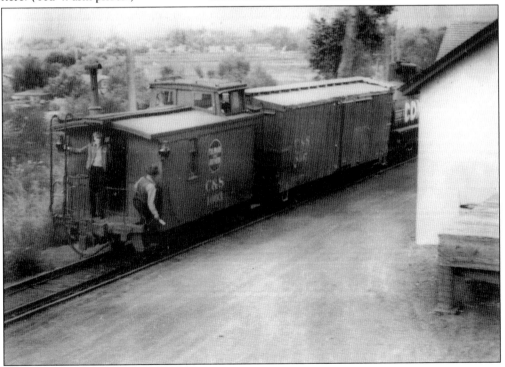

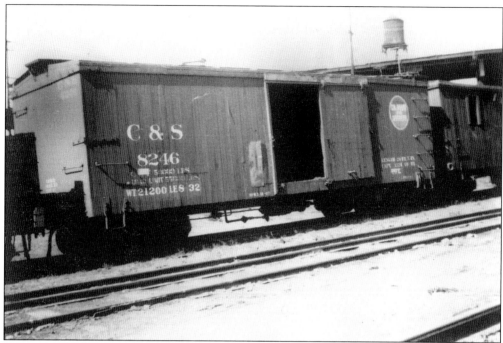

Boxcar No. 8246 was part of a series of 100 boxcars built by the C&S in 1909. These cars were 30 feet long, had steel underframes, and ran on Bettendorf trucks. Several dozen cars in this series survived to see service on the Rio Grande Southern.

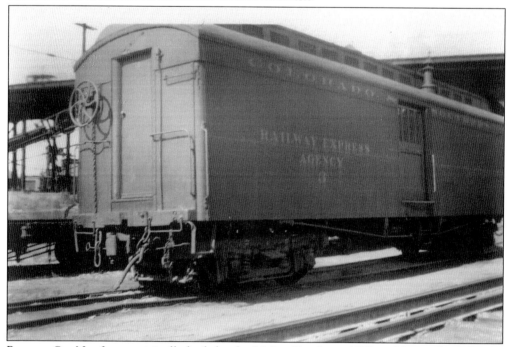

Baggage Car No. 3 was originally built by the Union Pacific in 1873 and later rebuilt by the Colorado & Southern in 1915. No. 3 was one of the oldest cars in the C&S fleet when it was retired in 1939.

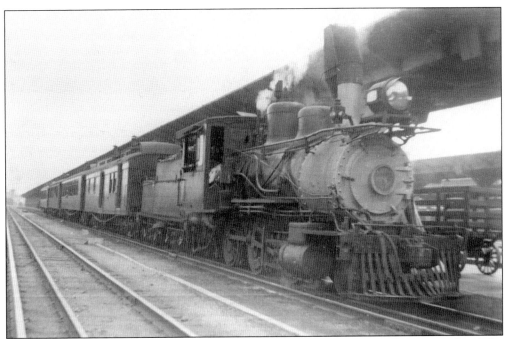

Even in the 1920s the three-railed track at Denver's Union Station still accommodated the narrow-gauge C&S. This photo shows Engine No. 71 preparing to make another run. The length of the train as well as the fact that one of the more powerful 2-8-0s is being used suggests that it might be headed for Como over the South Park line.

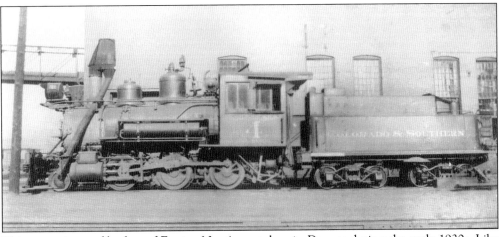

This very nice profile shot of Engine No. 4 was taken in Denver during the early 1930s. Like many of the other C&S Moguls, this engine was built by the Cooke Locomotive Works. It arrived as DSP&P No. 39 and later became DL&G No.109. After being rebuilt by the C&S in 1900 and again in 1917, this engine was scrapped in 1934.

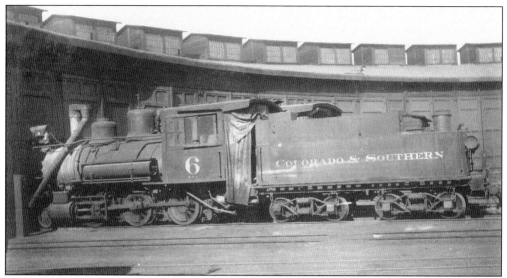

This photo shows Engine No. 6 at the Denver roundhouse late in its life and after many hard years of narrow-gauge service. Another Cooke product that dates to the days of the Denver, South Park & Pacific, this locomotive was a favorite with early photographers. A few months after this 1939 photo was taken, No. 6 was scrapped. (Robert Graham photo.)

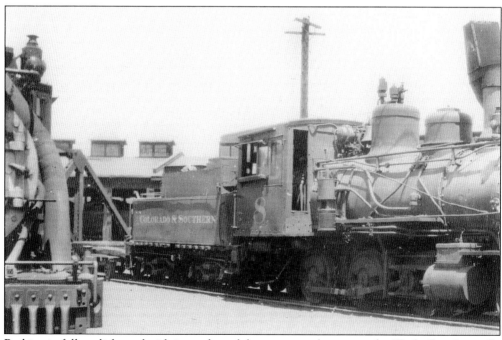

Basking in full sunlight and with its trademark bear-trap spark arrester, the "Eight Spot" proudly waits near the turntable of the Denver roundhouse. With no more passenger runs to make, this engine was relegated to light freight duty along the Clear Creek line. No. 8 was scrapped along with Nos. 5 and 6 in 1939.

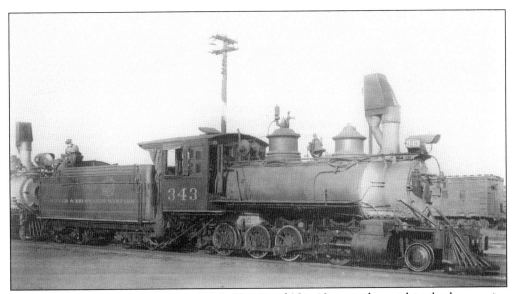

The decision of the C&S to scrap 2-6-0s No. 4 and No. 10 created a void in the locomotive roster. Although some engines were shuffled around to try and balance the motive power requirements, additional help was needed. The C&S found the answer in leasing three engines from the Denver & Rio Grande Western, one of which, C-16 Class 2-8-0 No. 343, appears in this photo taken in Denver in 1936. No. 343, along with sisters No. 345 and No. 346, were leased from 1935 until 1937. (William A. Gibson photo.)

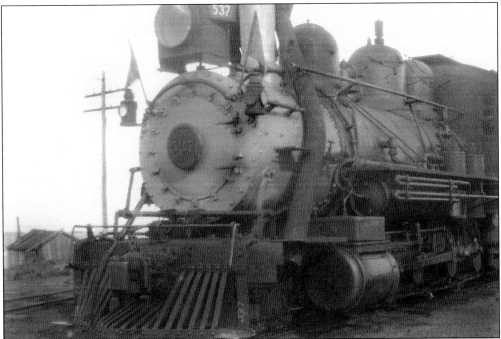

A symbol of the influence of the Chicago, Burlington & Quincy, which acquired control of the C&S in 1908, CB&Q No. 537 saw service on some of the steep grades of the Colorado & Southern. Originally built for the Deadwood Central, this locomotive was leased from the CB&Q from 1930 until it was scrapped in 1939.

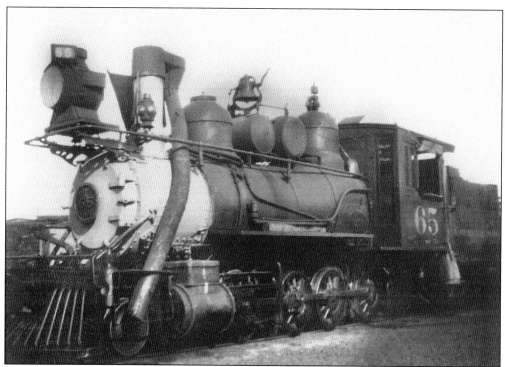

Like the Moguls, C&S 2-8-0 Consolidations were also fitted with the Ridgway (bear-trap) spark arresters. This image of No. 65 was taken prior to receiving the more up-to-date headlight with which she would finish out her last days.

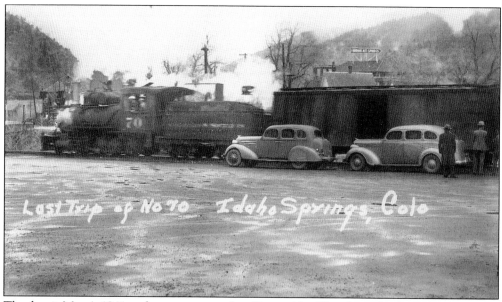

The date is May 4, 1941 and spectators watch as Engine No. 70 makes a final run through Idaho Springs where emptied cars were collected and returned to Golden. The scrap train headed by Engine No. 69 would return a week later.

Ten

CLEAR CREEK IN THE MODERN ERA

After World War II, America began to travel again and the highways that had once spelled doom for the C&S now brought in automobiles full of tourists. The donation of C&S Engines No. 60 and No. 71 to Idaho Springs and Central City, respectively, helped visitors to make the connection between the Clear Creek of the present and the Clear Creek of the past. Throughout the 1950s interest in both the railroad and the region increased. By the late 1960s a group of Colorado railroad enthusiasts contemplated the rebuilding of the most famous portion of the line from Georgetown to Silver Plume. Such an undertaking would require the relaying of rail and, more importantly, rebuilding the "High Bridge." In 1973, this dream became a reality. Rail fans joined with the Colorado State Historical Society and the combined efforts of the U.S. Army and Navy, local railroads, and a large group of volunteers all dedicated to trying to rebuild "The Loop." By 1975 the railroad was back in use and once again locomotive smoke filled the Clear Creek Valley. Today the Georgetown Loop Railroad sustains a tradition that was started with the Colorado Central as trainloads of passengers continue to marvel at the beauty of Clear Creek.

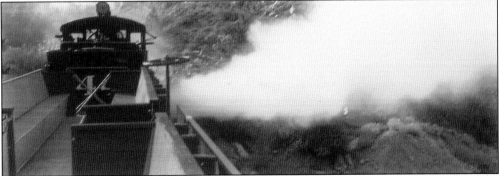

Narrow-gauge railroading returned to Georgetown in the 1970s. Through the diligence of the Colorado State Historical Society and many volunteers, The Loop was rebuilt and used steam engine No. 44.

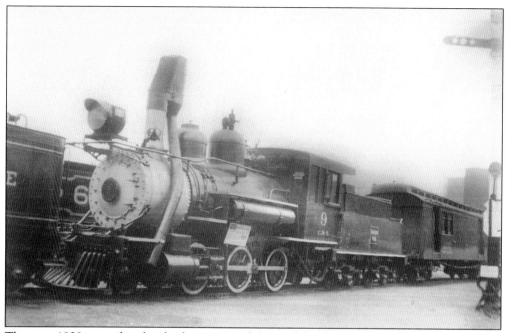

The year 1939 proved to be the beginning of the end for the Colorado & Southern's Clear Creek Line. While preparations were being made to scrap most of the narrow-gauge engines that remained, C&S No. 9 was given a fresh coat of paint and sent to the East Coast. This photo shows No. 9 on display in New York City as part of the Transportation Exhibit at the 1939–1940 World's Fair.

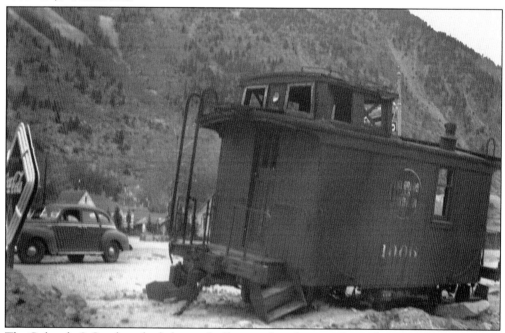

The Colorado & Southern had plenty of rolling stock to dispose of as well. Some of its equipment went to the Rio Grande Southern while some was sold off to scrap dealers. This photo shows Caboose No. 1006 at Silver Plume around the time the C&S was abandoned.

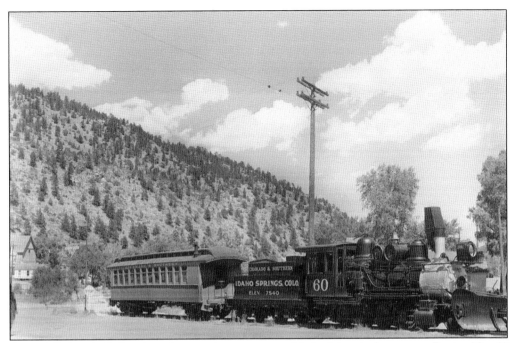

Several Colorado & Southern locomotives were set aside for historical purposes. Engine No. 60 was donated to the town of Idaho Springs, which placed the engine and a passenger car on rails and painted them up as a welcome banner.

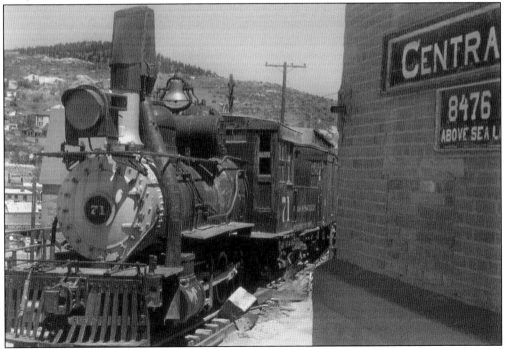

Another locomotive that was lucky enough to escape the scrap yard, Engine No. 71 was donated by the C&S to the town of Central City. This 1970s photo shows where it was placed on display surrounded by the community it once served.

Throughout the 1930s the roads around Clear Creek were improved and saw heavier use from automobiles and trucks. This photo shows highway construction workers installing a guardrail near Fall River.

Along with the Clear Creek highway improvements came paved roads, better bridges, and even tunnels. Today, one can only imagine how the narrow-gauge engines might have appeared coming out of a tunnel like this one.

By the 1930s the depot at Silver Plume was no longer being used and after the demise of the C&S was abandoned all together. A group of historic minded individuals were able move the depot during the construction of Interstate 70 and save the building from demolition. This photo shows how the depot appeared around 1965. Ten years later it would become part of the new Georgetown Loop Railroad.

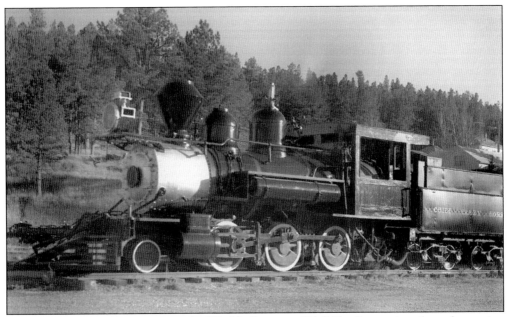

The good fortune of being sent to the World's Fair gave C&S No. 9 a reprieve from the cutting torch. This little Mogul would eventually be sent to South Dakota, where it served the Black Hills Central. When this photo was taken, "Chief Crazy Horse" appeared on the engines tender.

Post–World War II travel saw a marked increase in the amount of tourist who came to Clear Creek. This late 1950s photo shows Colorado vacationers and their camper west of Clear Creek on Berthoud Pass.

In 1947 the Colorado State Historical Society erected a marker near the former site of the Georgetown Loop telling travelers the tale of when the railroad was built and dismantled. At that time few could imagine that a steam railroad would return to The Loop 25 years later.

In the 1950s, some tourists who arrived at Idaho Springs apparently had a full appreciation of the history of the area. In this photo, a vacationer recreates a scene from the past, panning for gold in Clear Creek.

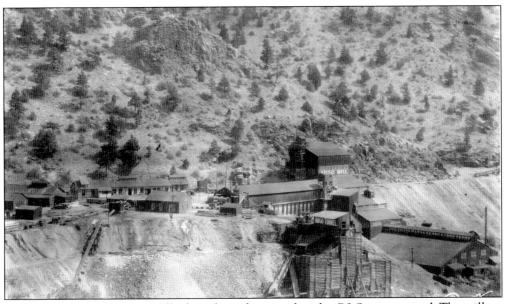

This photo shows the Argo Mill taken about the time that the C&S was scrapped. The mill sat close to the new highway and became a point of interest with passing travelers.

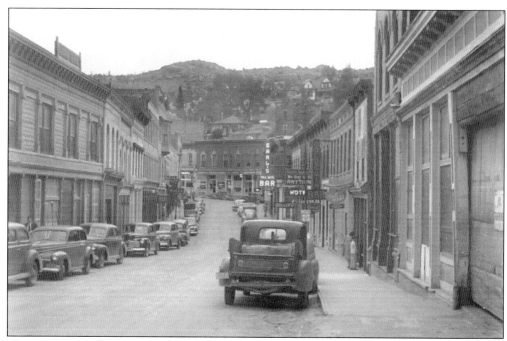

The resurgence of auto traffic into the communities of Clear Creek helped to create scenes like this. By the late 1940s, Central City no longer had a railroad but, according to this photo, there were no shortages of bars.

Nevadaville, one of the former Gilpin Tramway towns, did not share in the Central City renaissance. By the 1950s, this was how Nevadaville appeared to a photographer who pointed his camera out of a vacant building toward the bell tower of the old firehouse.

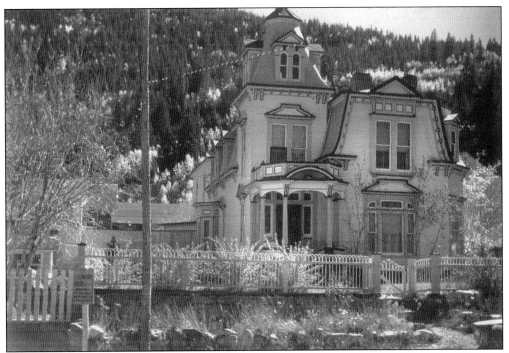

Although some of the smaller Clear Creek towns began to fade away, Georgetown held on to much of its 19th-century charm and character. One of the reasons for this was houses like this one, which had been well maintained, providing visitors with a glimpse of Victorian architecture.

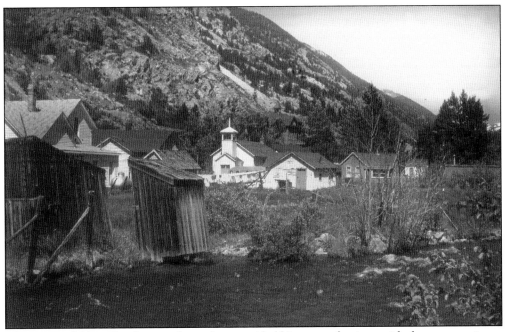

The towns of Clear Creek were places that provided history enthusiasts with the opportunity to spend hours climbing the hillsides to get a look at abandoned mines or wandering through back streets in search of miners' cabins, old churches, and even floating outhouses.

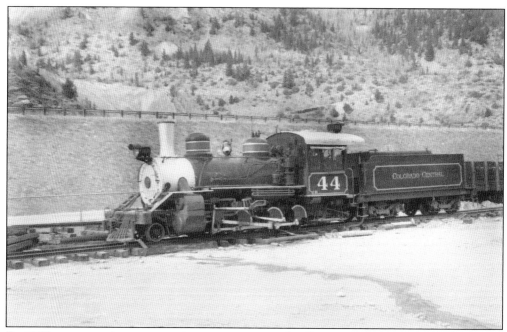

By 1975, steam engines were again operating over the Georgetown Loop, exposing a whole new generation to the thrill of narrow-gauge railroading. The operators of the railroad had not forgotten The Loop's history, and lettered Engine No. 44 for the Colorado Central.

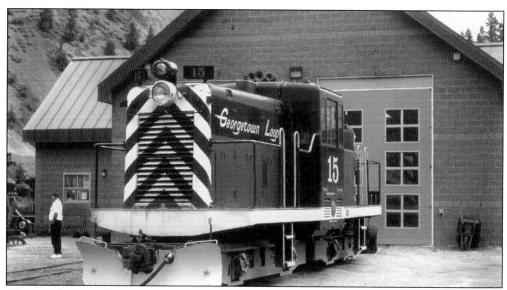

Along with several steam engines, the Georgetown Loop also acquired several diesel engines. This switch engine once served the Oahu Railway but by 1980 was carrying passengers as the Georgetown Loop Railroad No. 15.

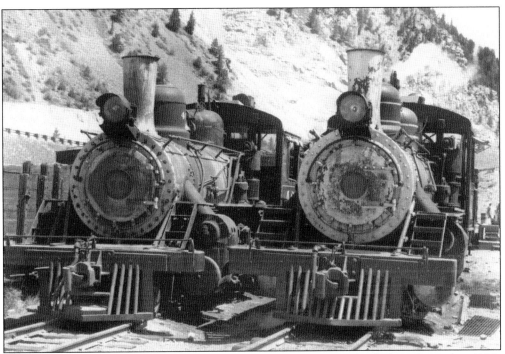

Two Georgetown Loop steam engines, No. 40 and No. 44, stand side by side in this 1980s photo. The structure in the background is the railroad's Silver Plume depot.

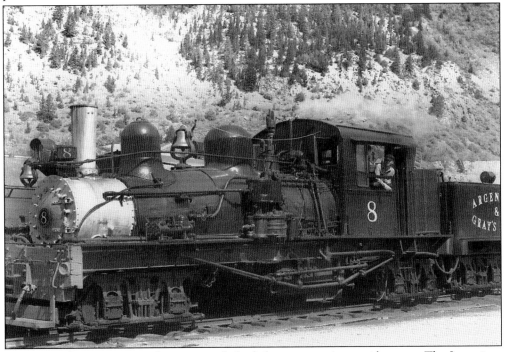

Visitors to the Georgetown Loop not only had the opportunity to ride across The Loop in a steam engine but were also able to get a rare look at a Shay engine. Lettered for the Argentine & Grays Peak, Locomotive No. 8 once worked for the Westside Lumber Company.

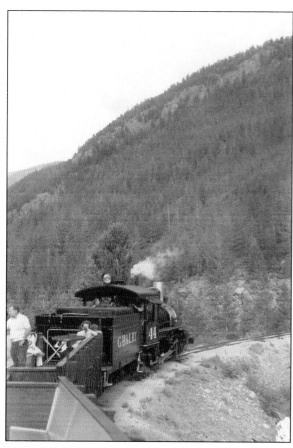

During its history on the Georgetown Loop, Engine No. 44 bore the name of several different railroads. In this photograph, the engine is lettered for the Georgetown, Breckenridge & Leadville, the railroad originally charted to build west from Georgetown in the 1880s.

The "High Bridge" was rebuilt thanks to the efforts of the U.S. Army Corps of Engineers and the Navy Seabees. This image, taken by photographer Chip Sherman in 1984, shows a double-headed train being pulled by a pair of Shay engines. (Chip Sherman photo.)

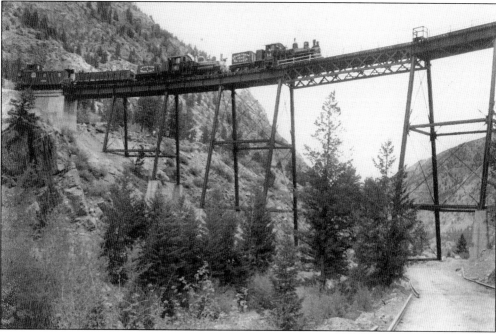